QUIRKY BOTANICALS and FRIENDS
A PLAYFUL THERAPY COLORING BOOK

by Floating Lemons

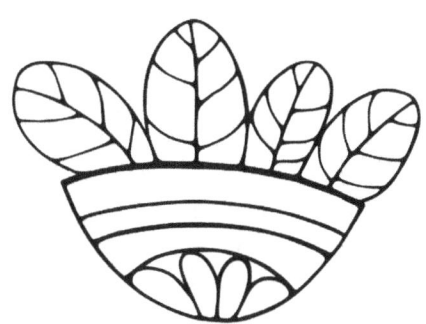

Features hand-drawn, whimsical, playful illustrations by Mariana Musa. Each black-lined illustration is accompanied by a grey-lined version so that colourists can experiment with different media. Designs are on one side of the page only.
Play, have fun and enjoy bringing colour to life!

A bit of advice:
Place a blank sheet of paper under the page that you're coloring to prevent indentations or bleed through onto the page under it.

design@floatinglemons.com
www.floatinglemons.com
www.floatinglemonscolor.com

copyright 2017 Mariana Musa. All rights reserved.

Permission is granted to those who wish to post copies of the pages of this book online as part of a book review.

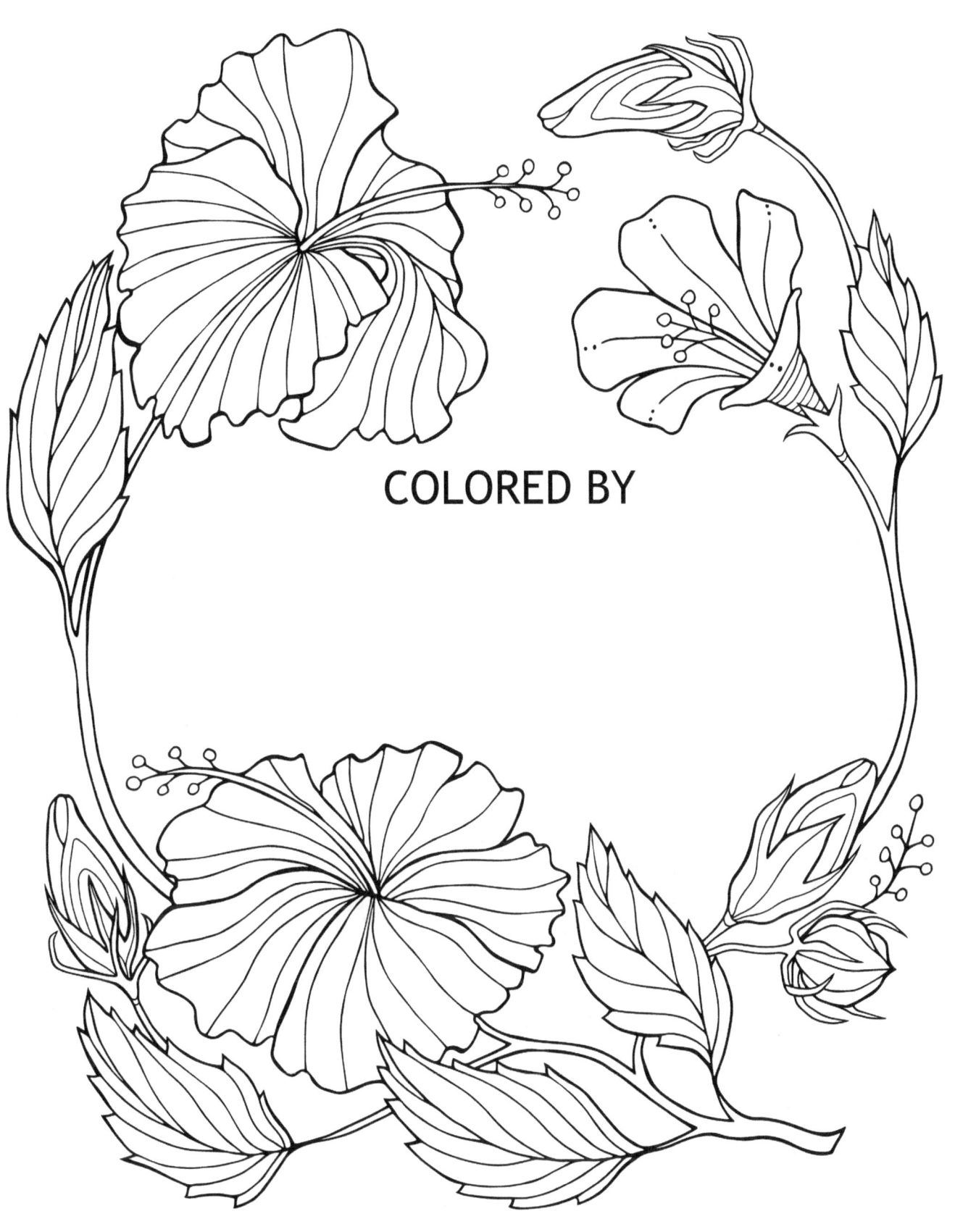

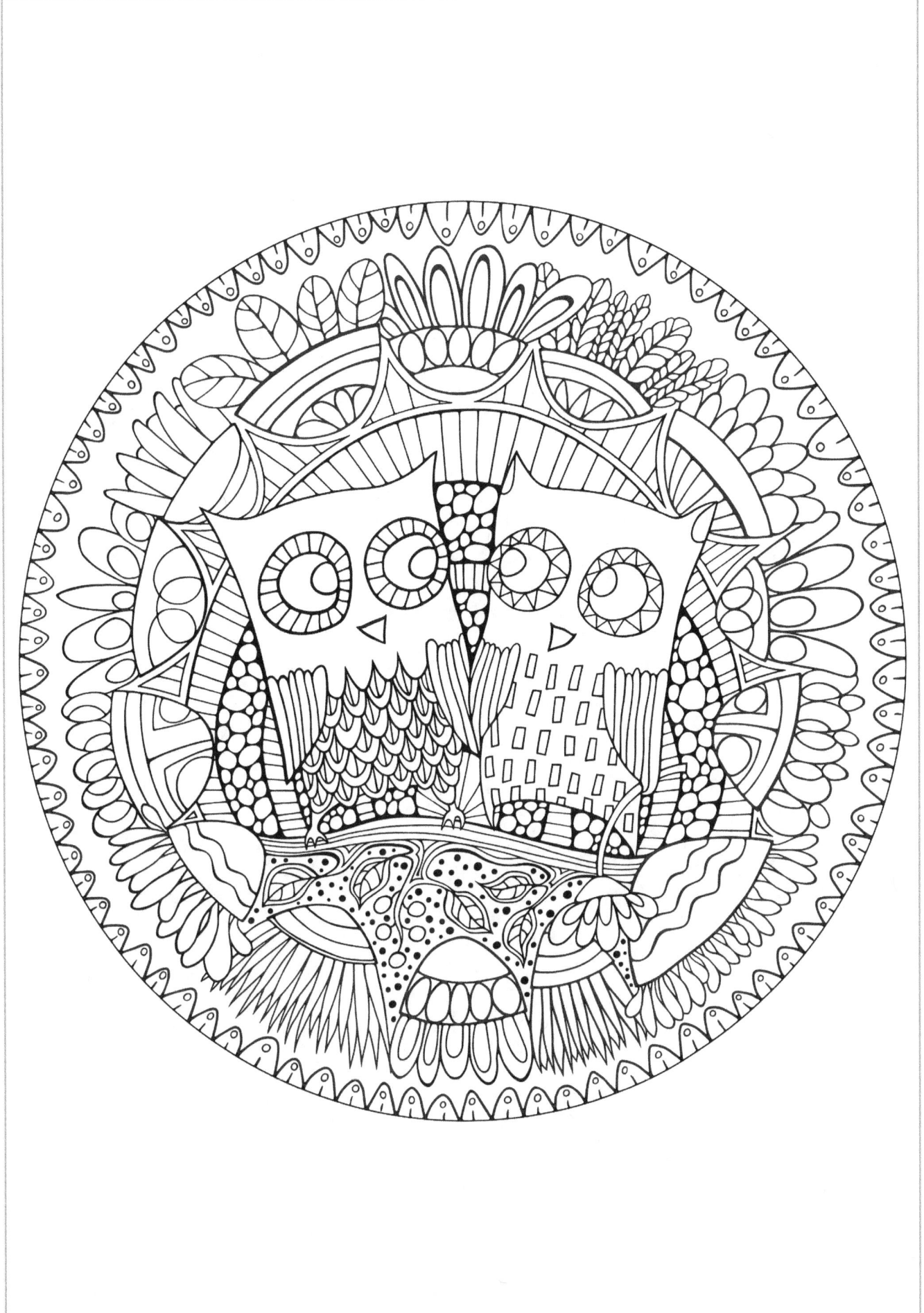

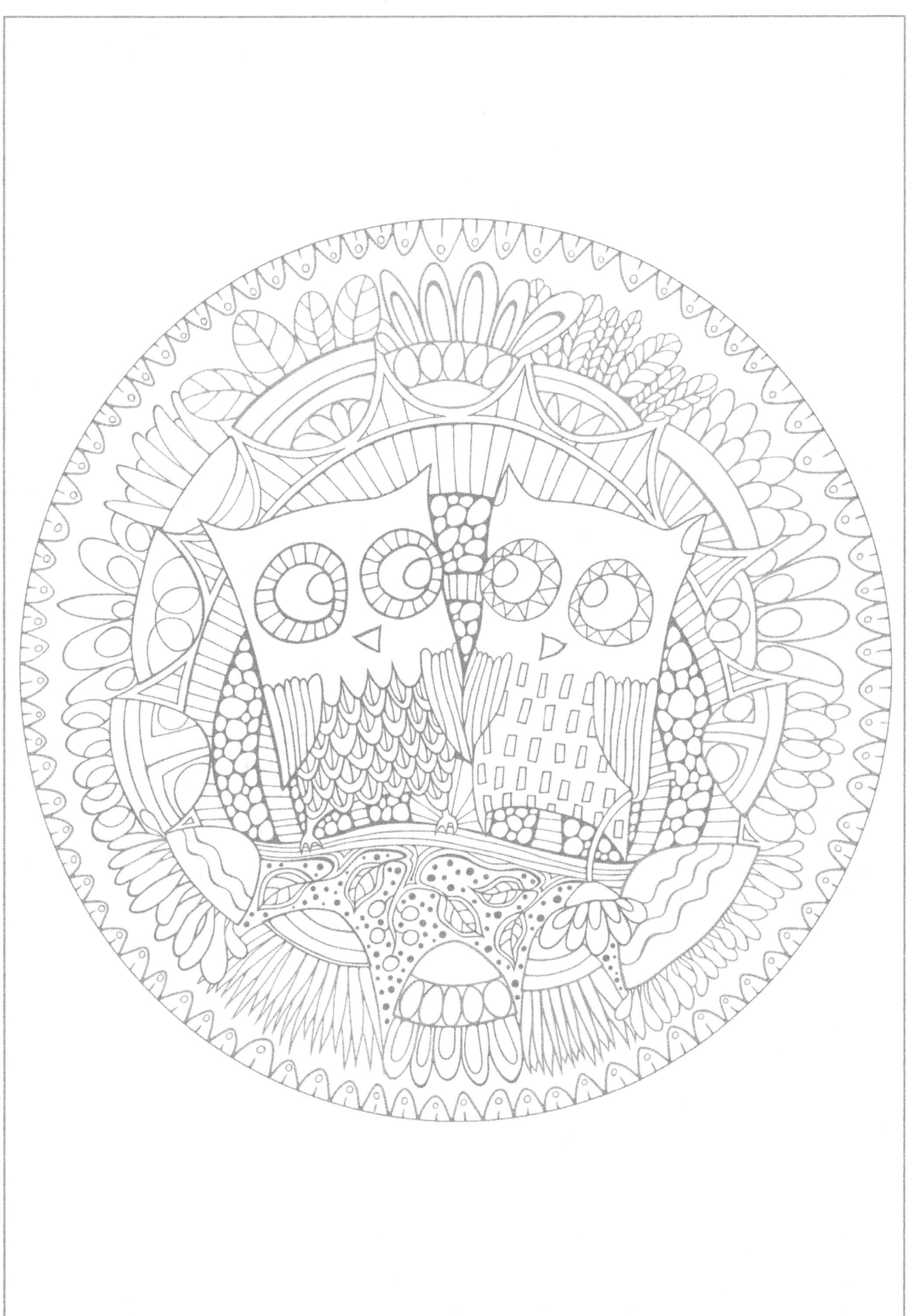

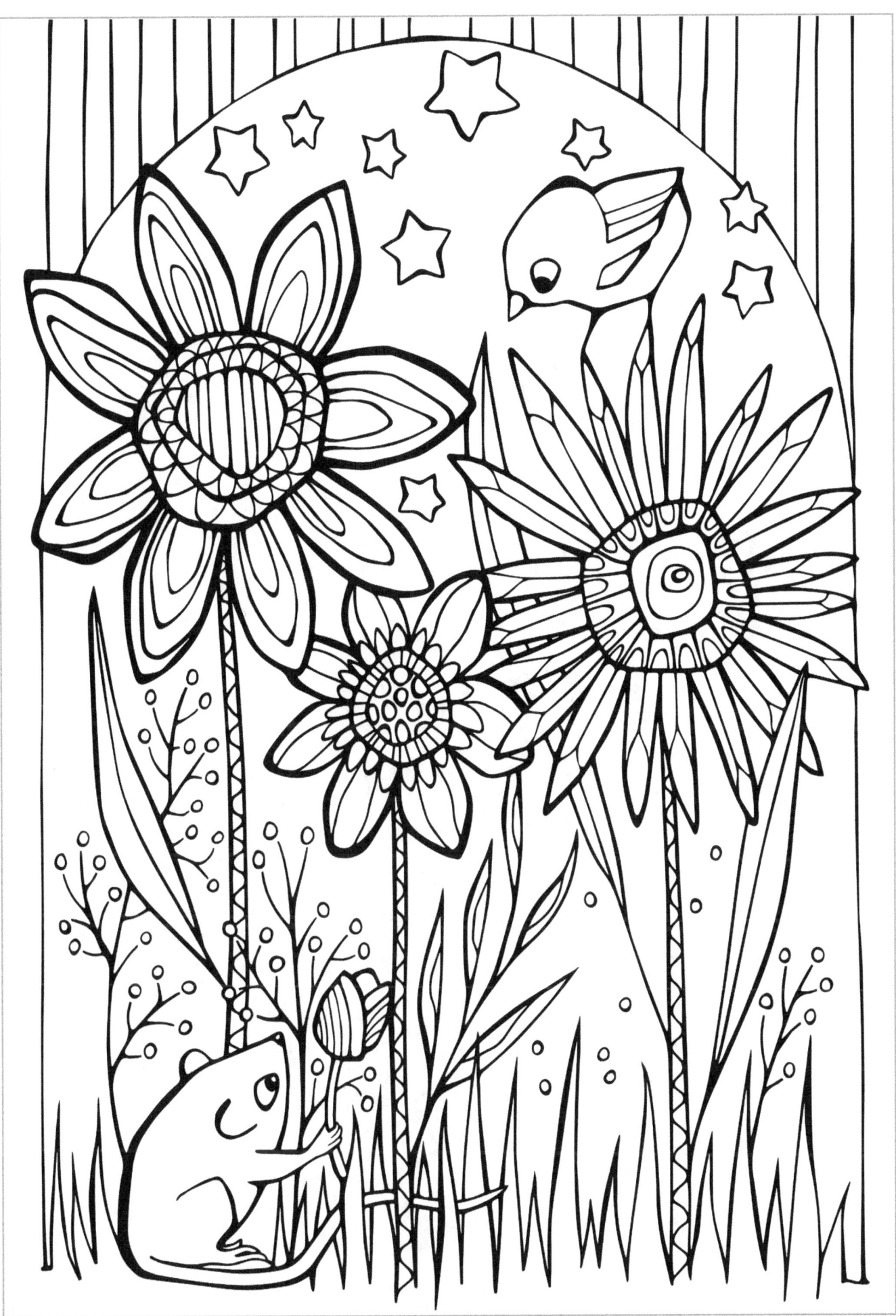

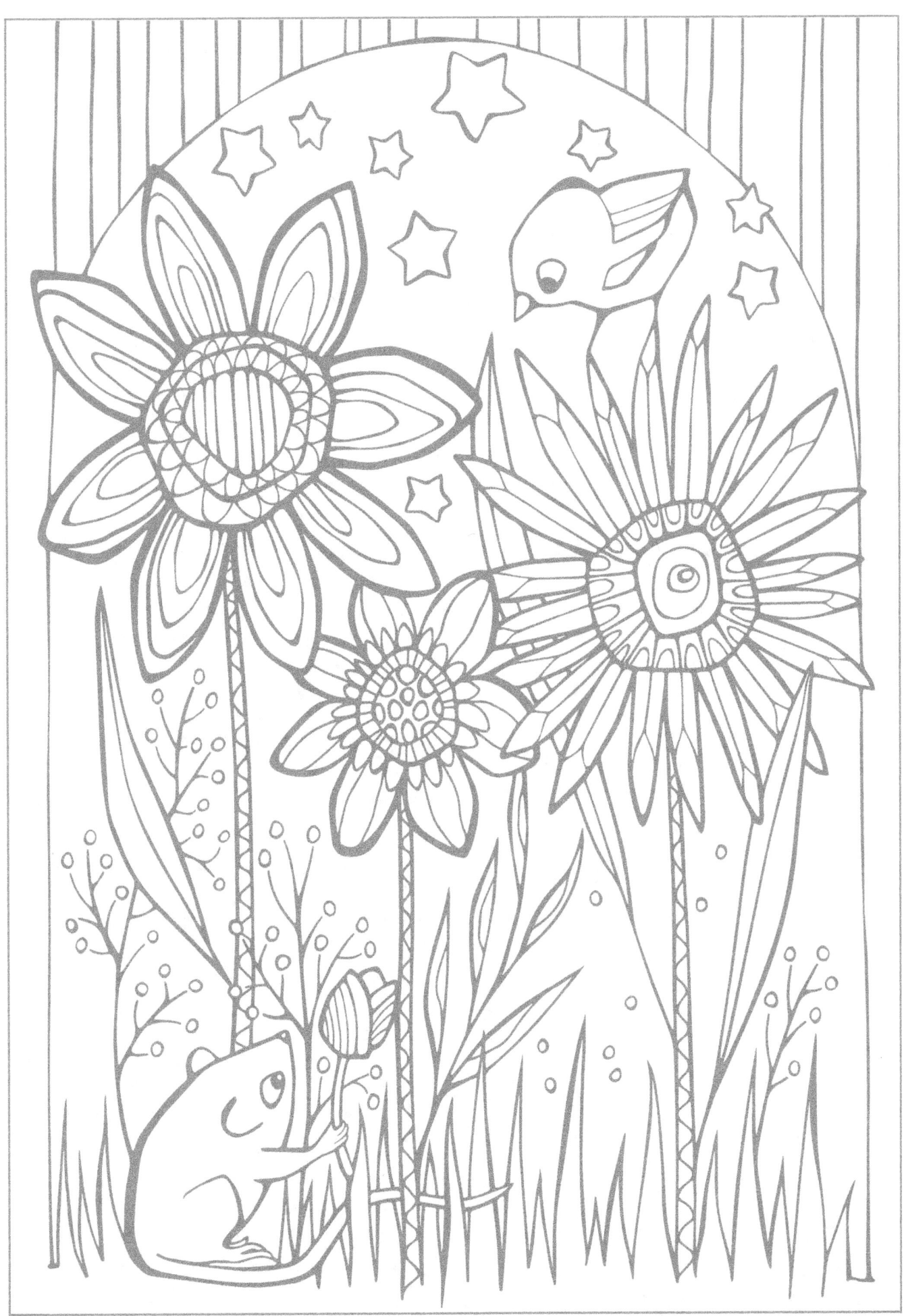

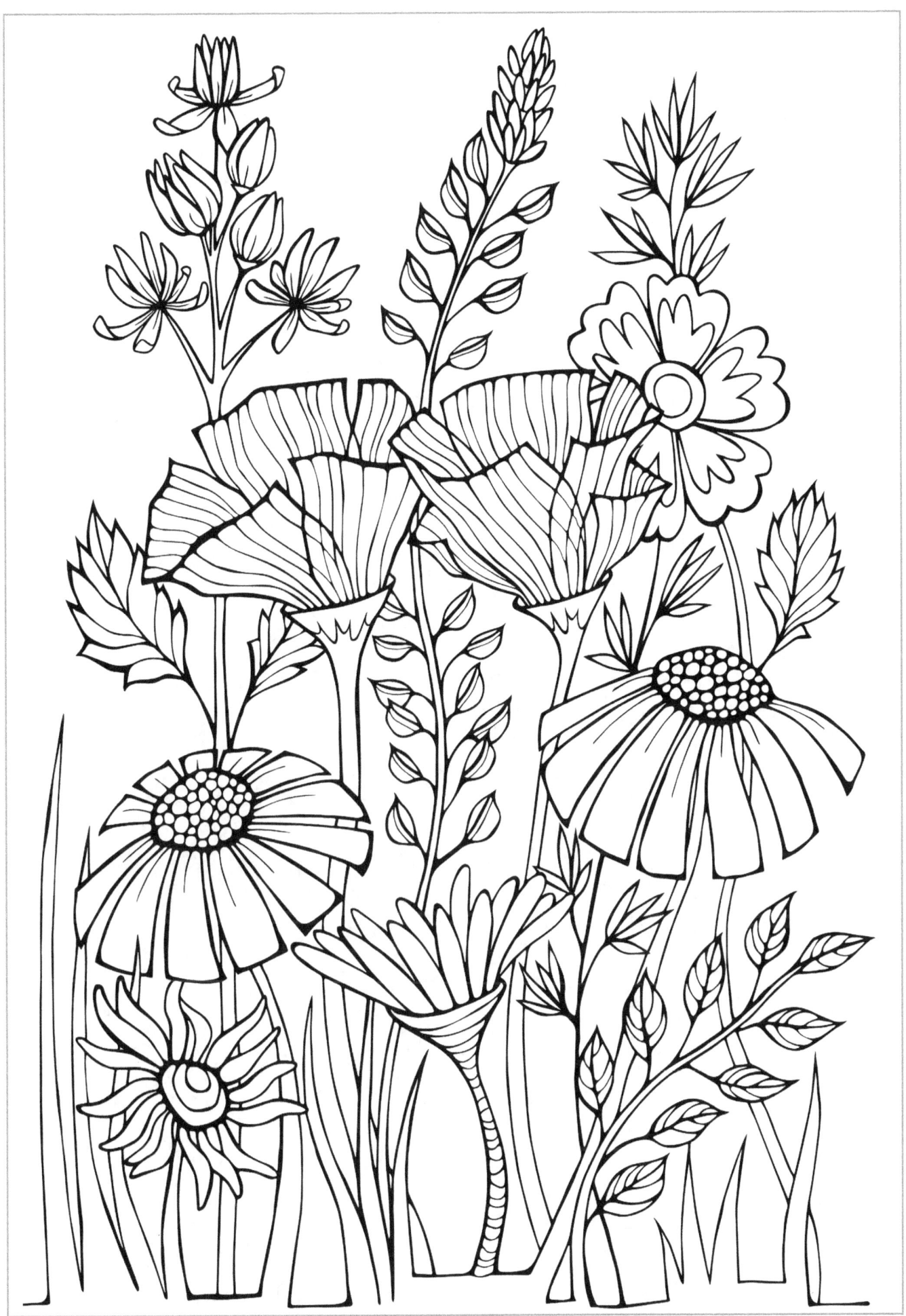

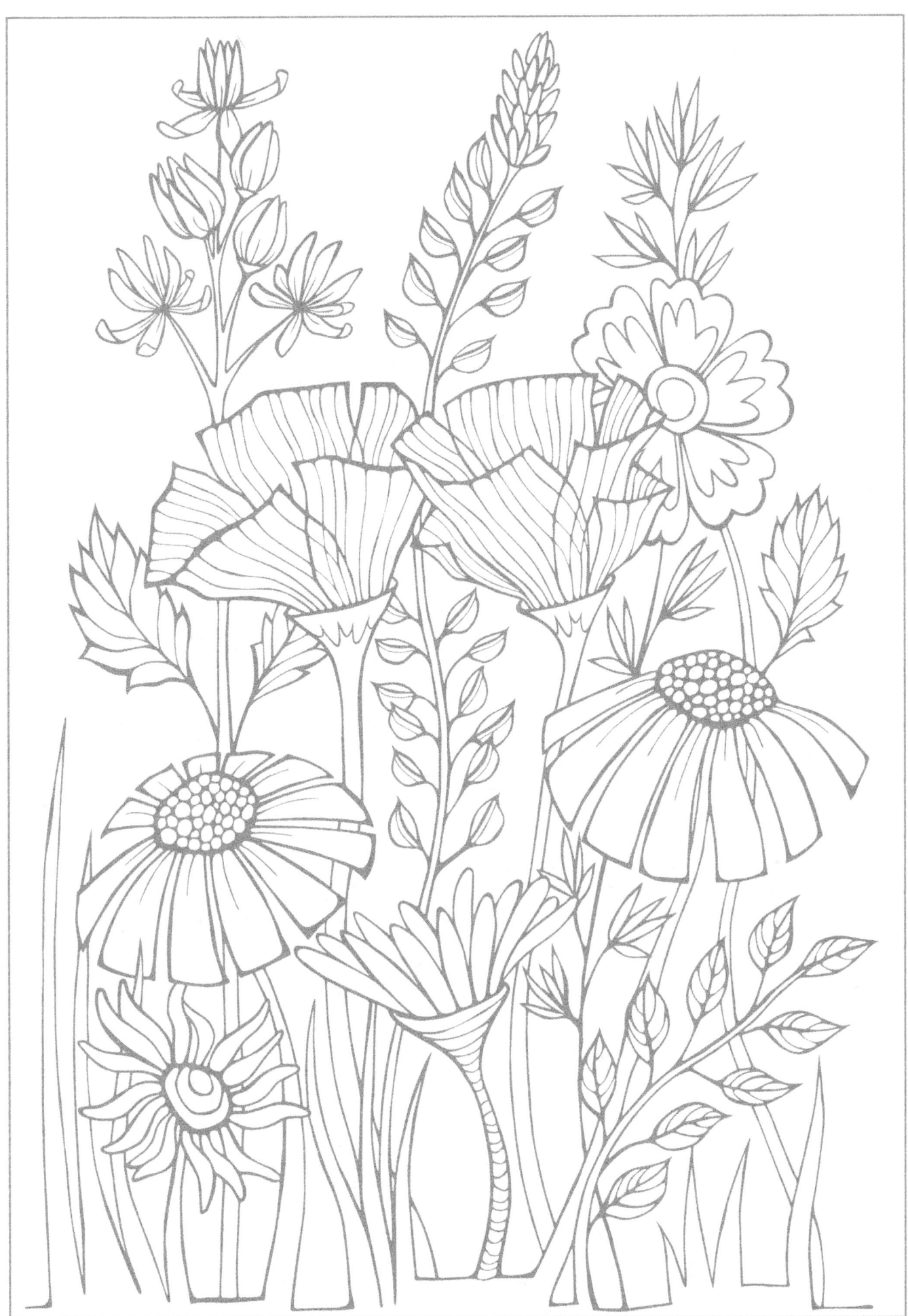

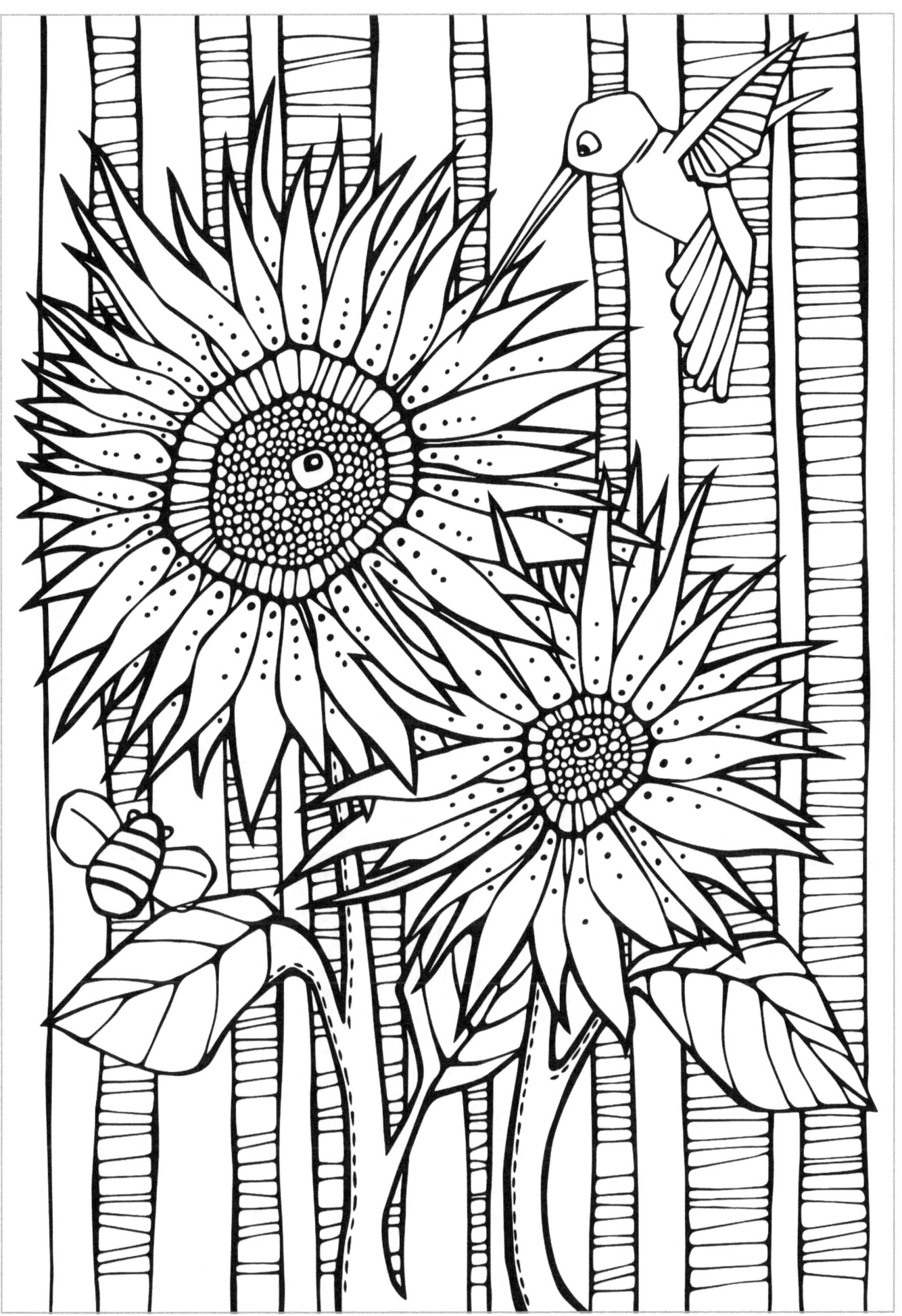

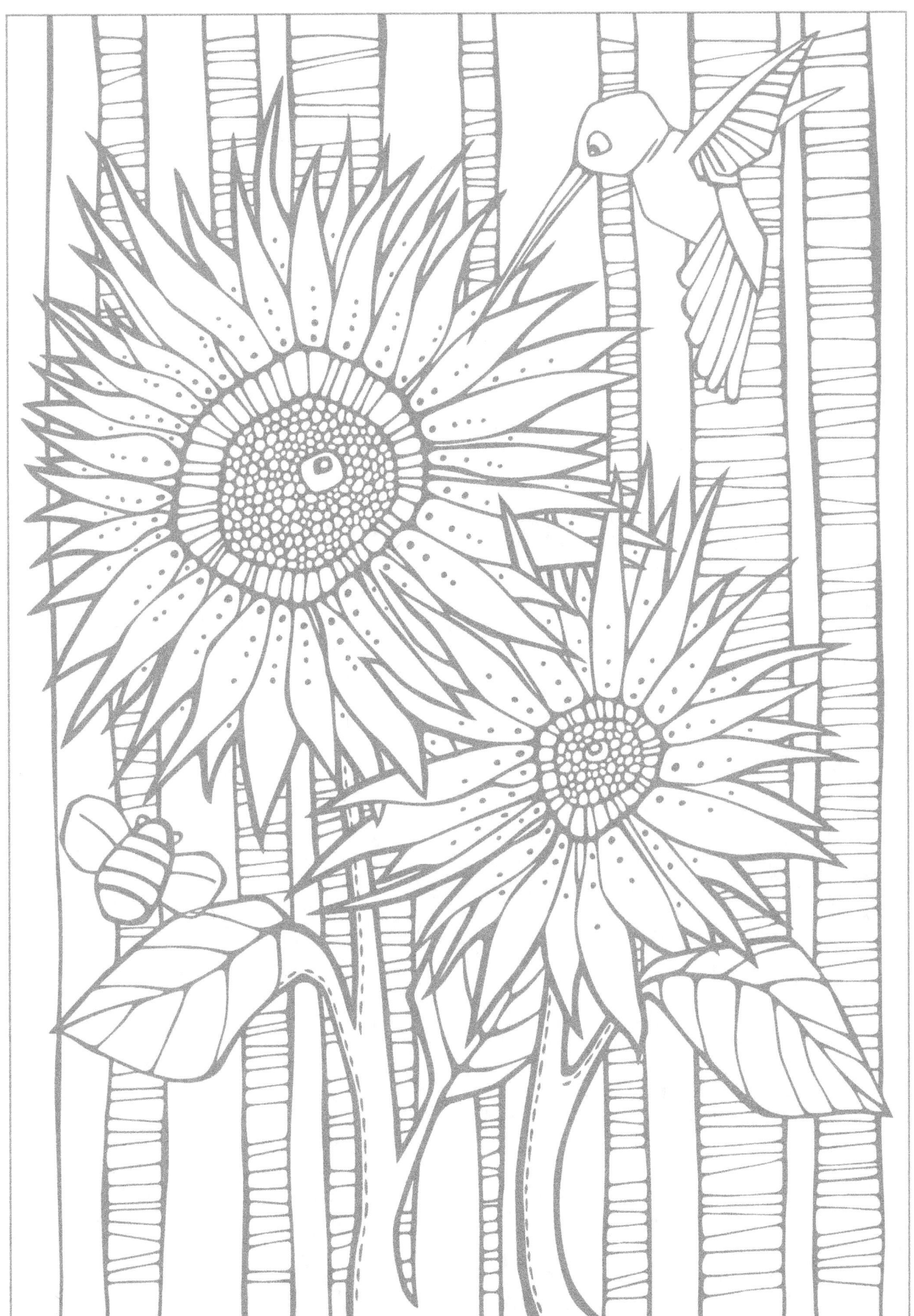

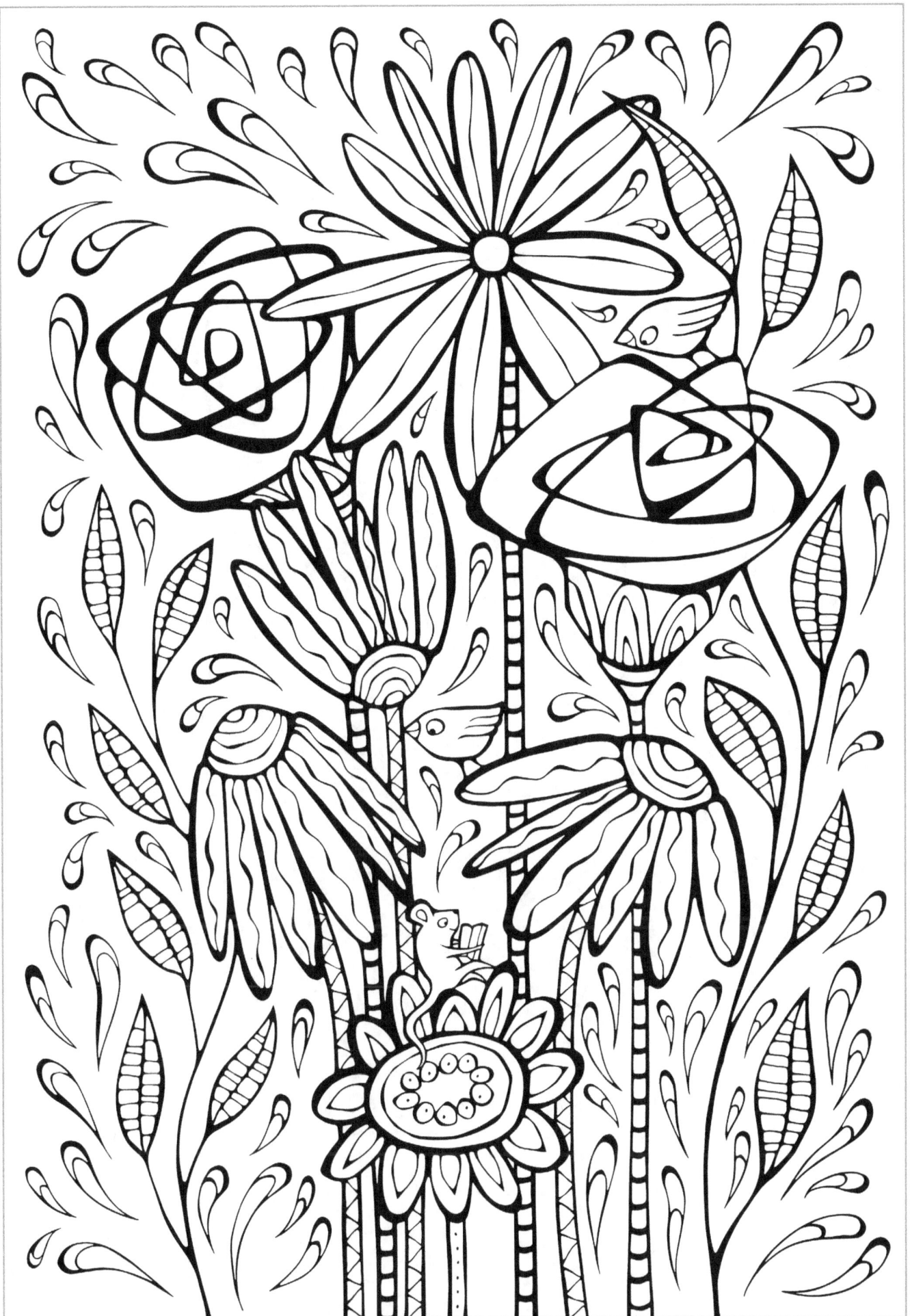

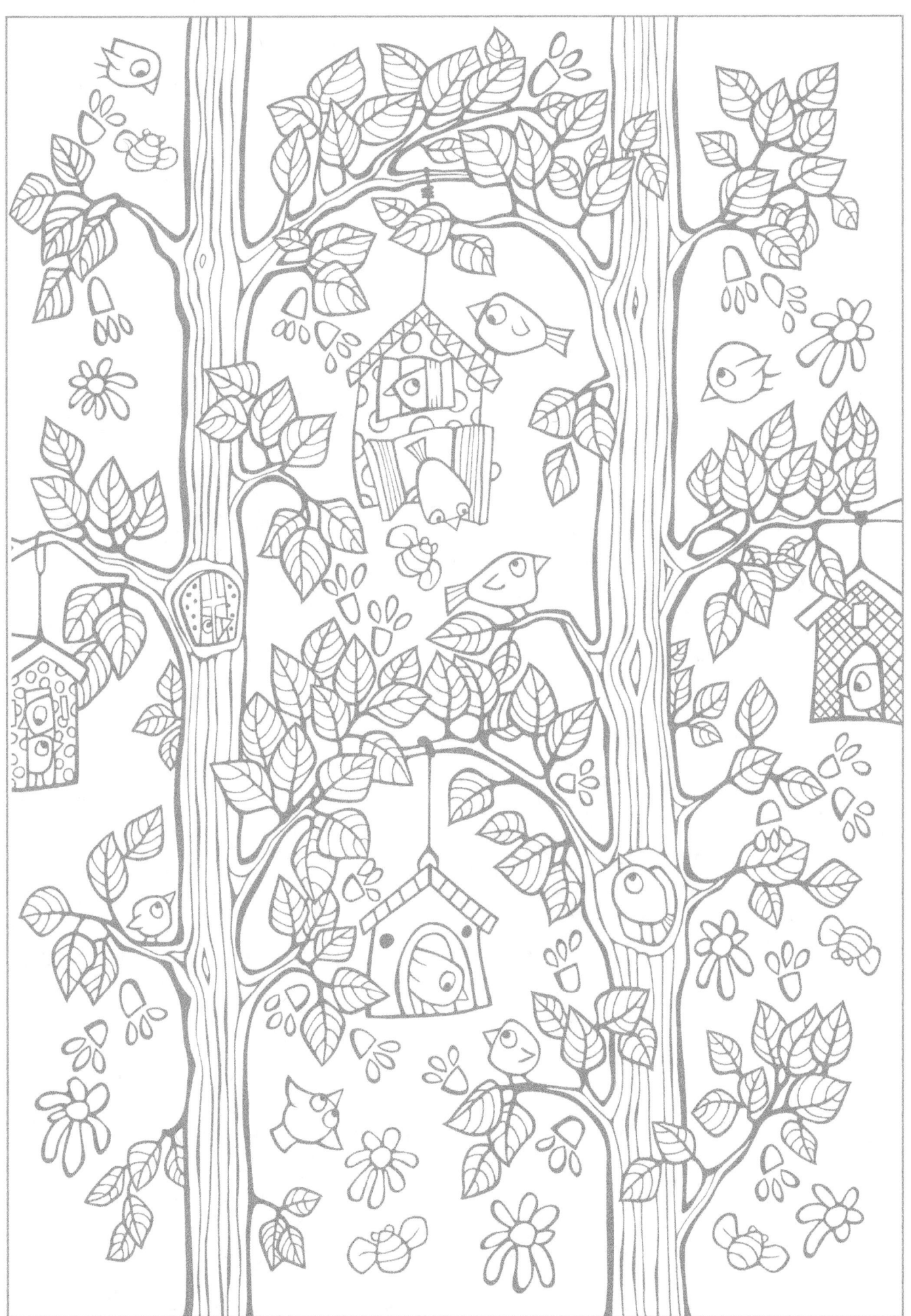

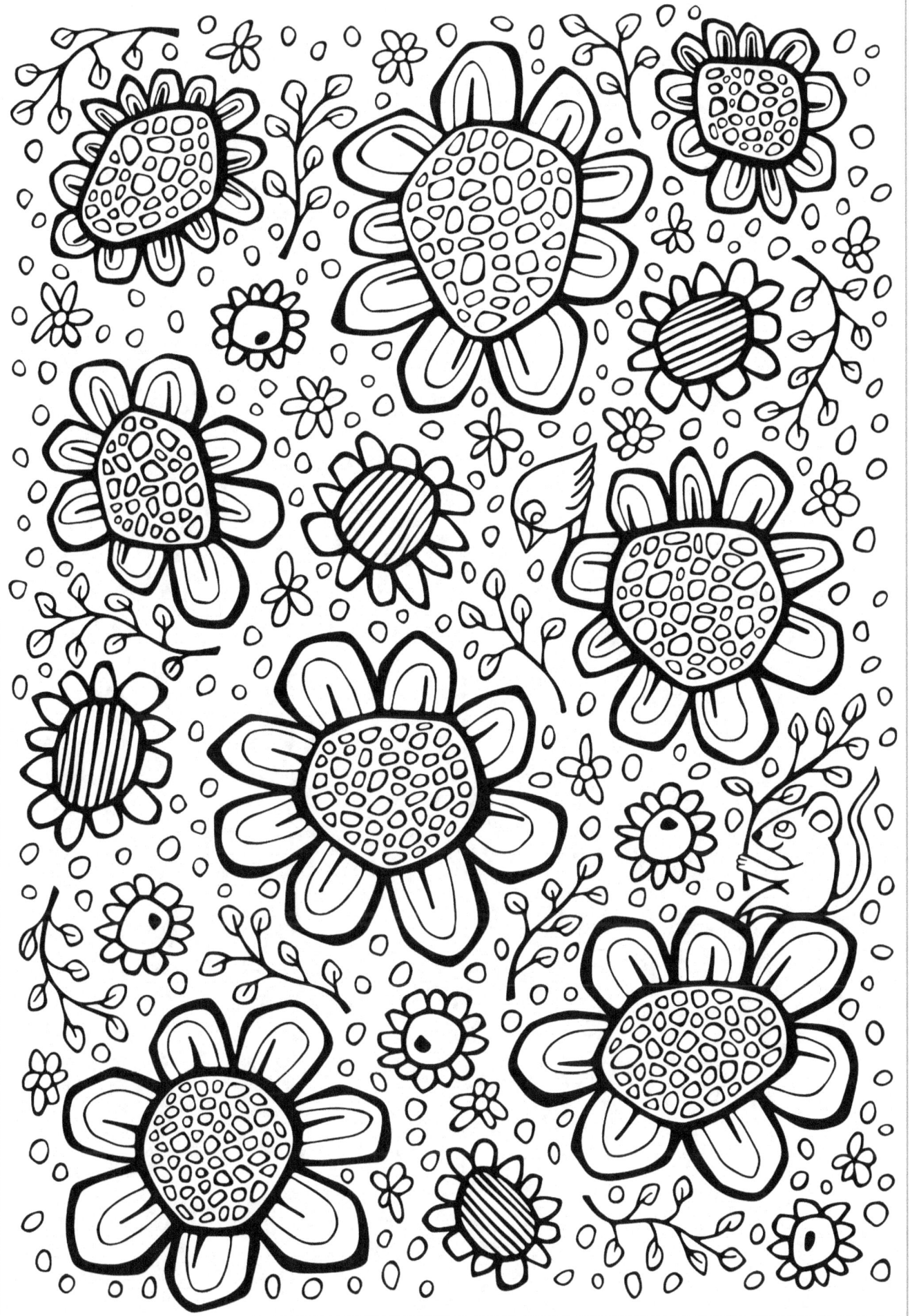

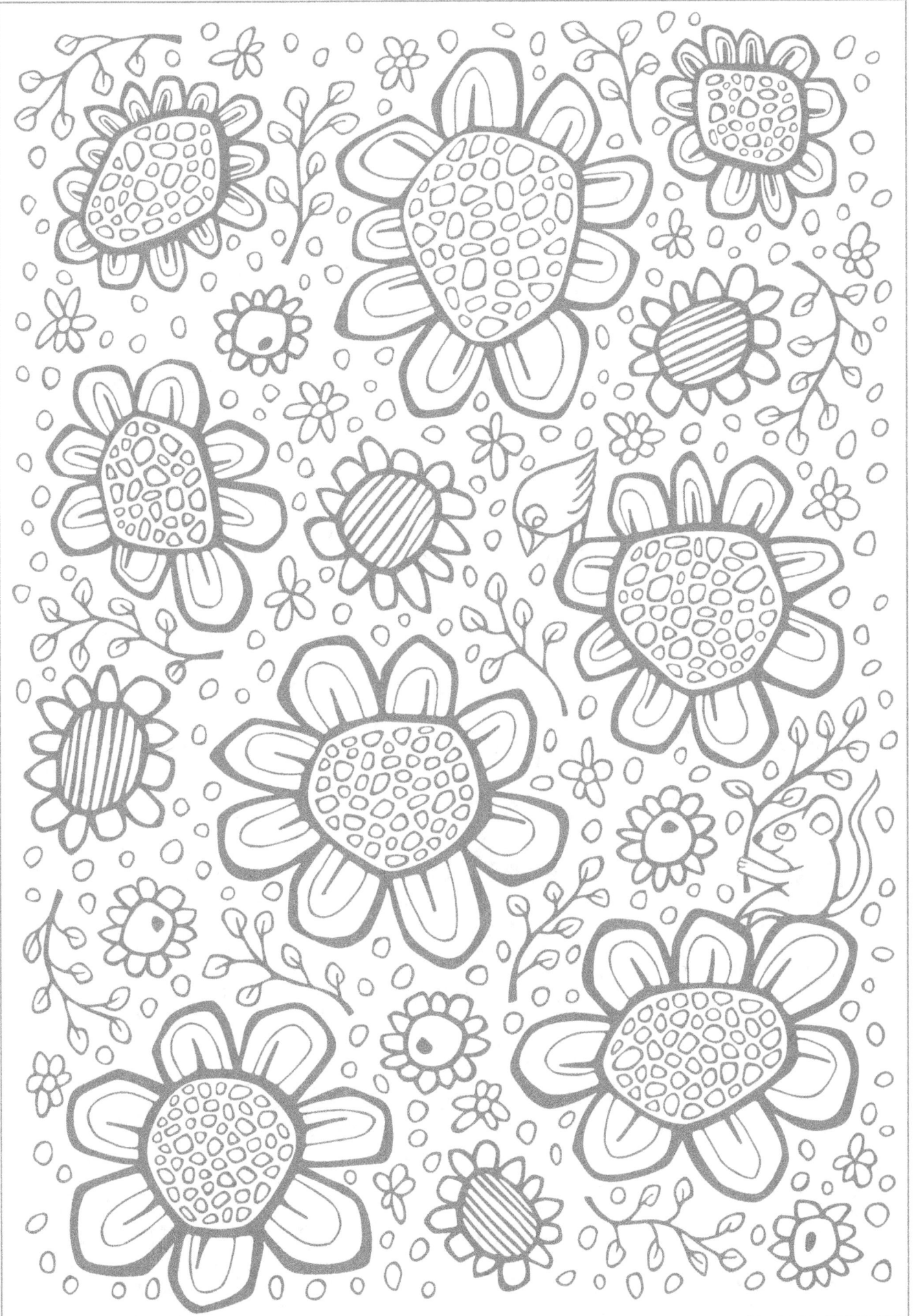

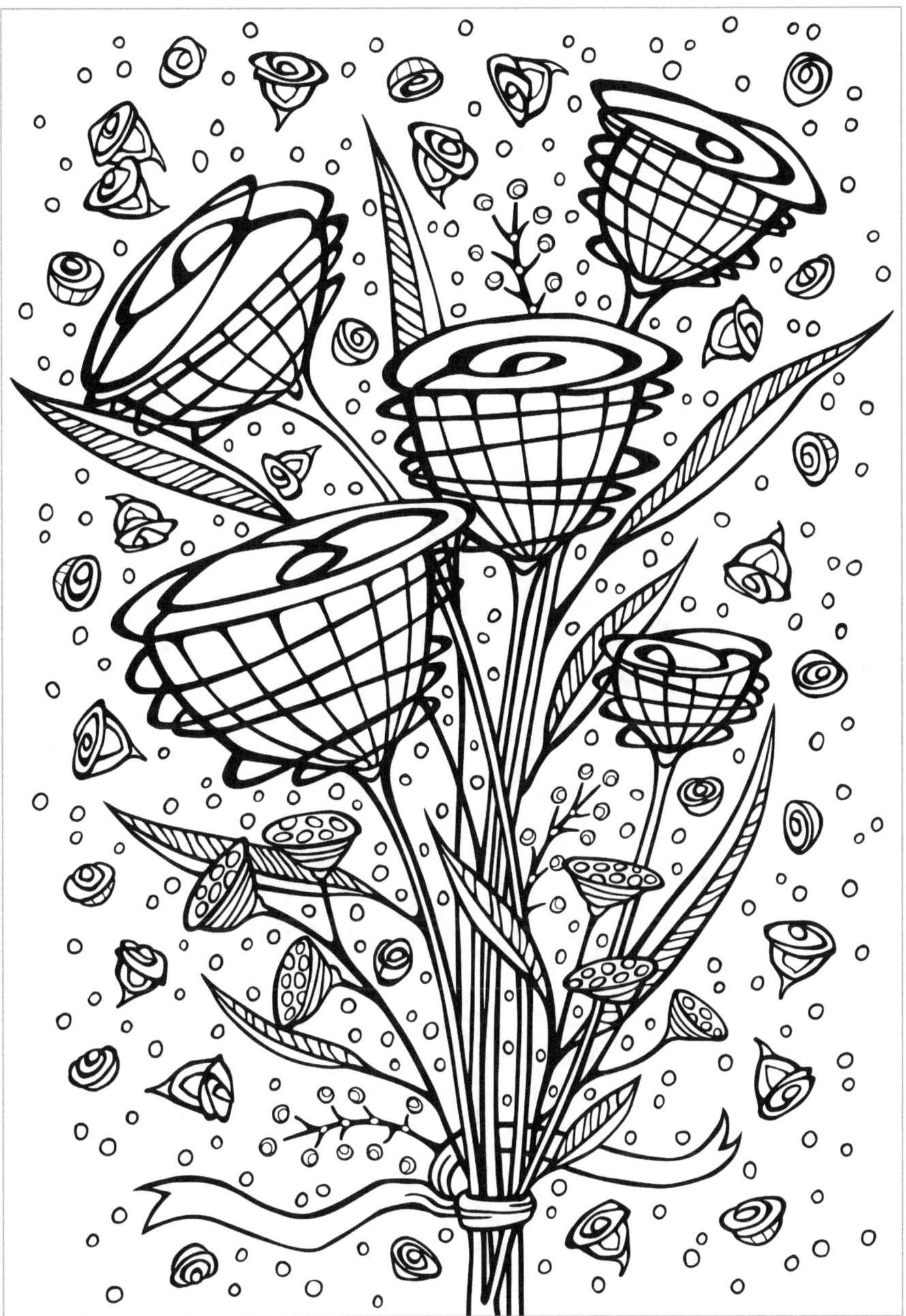

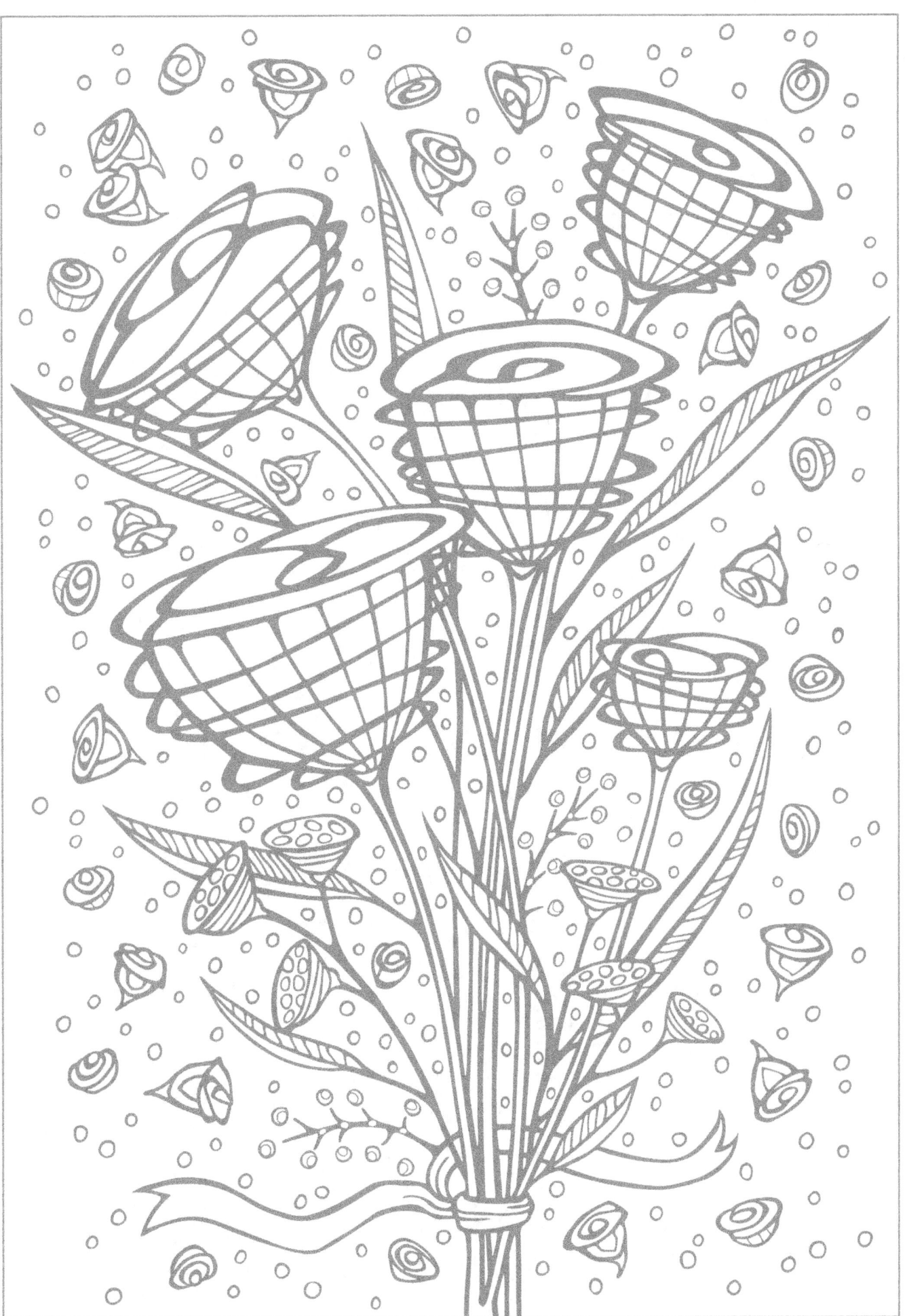

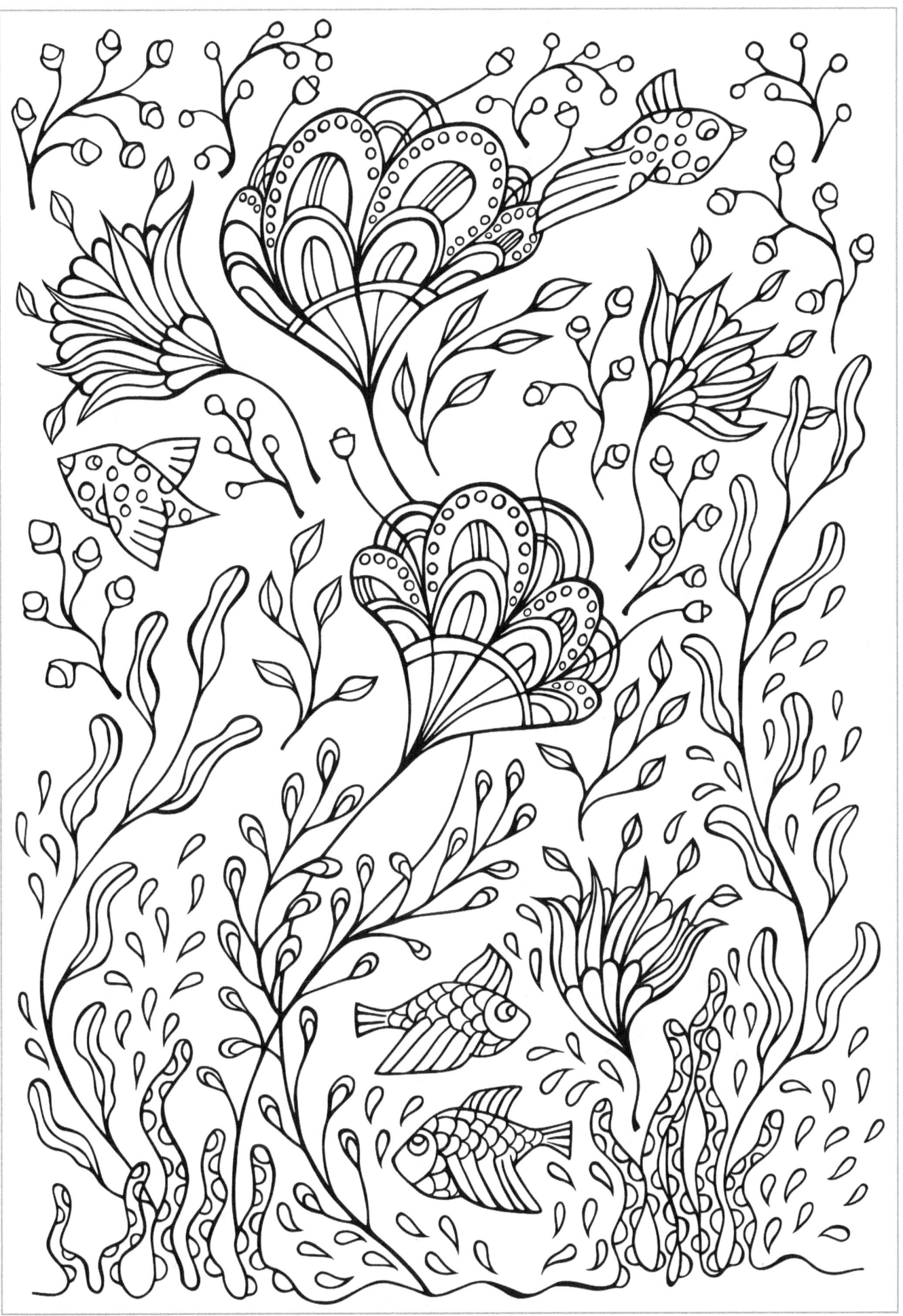

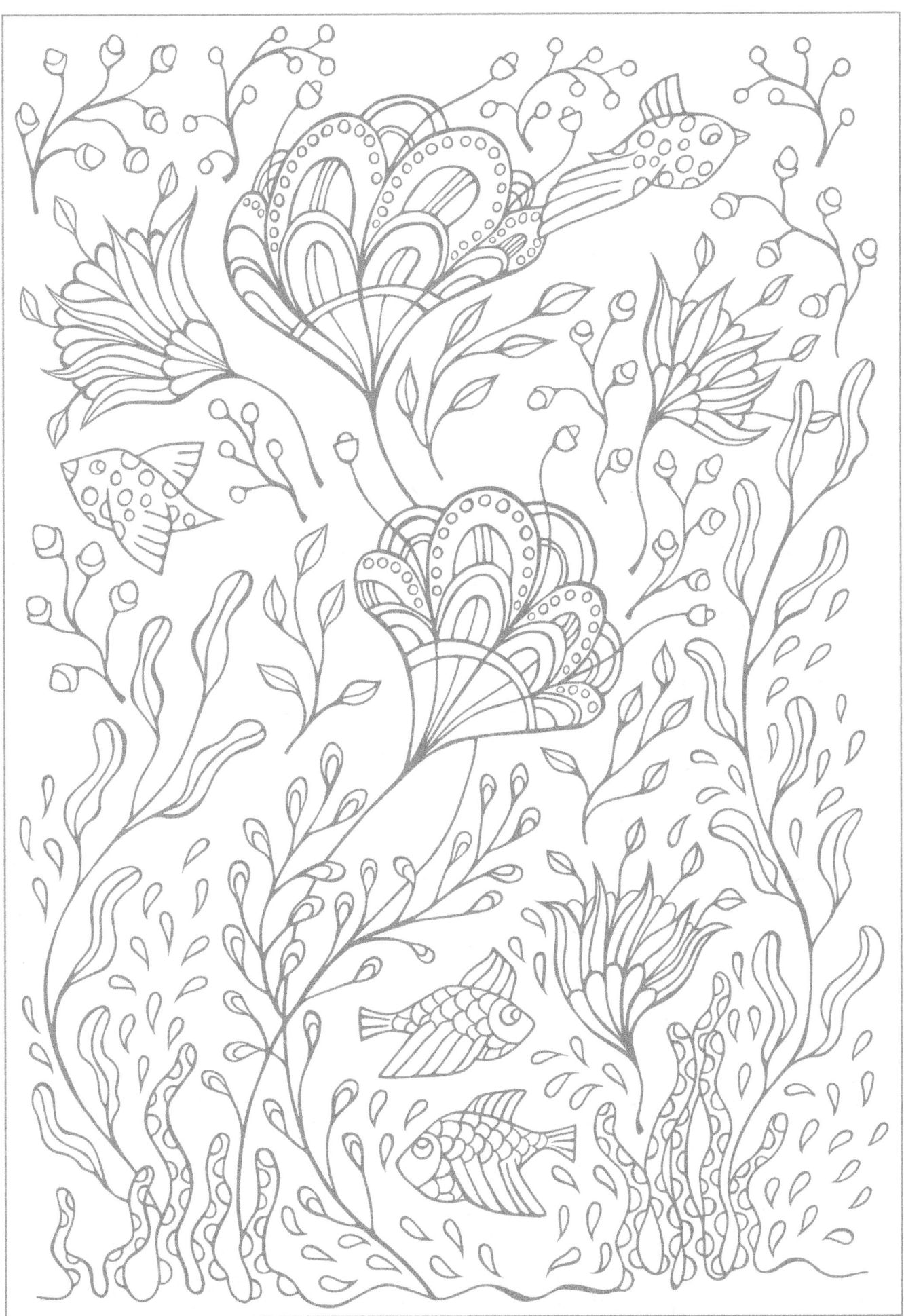

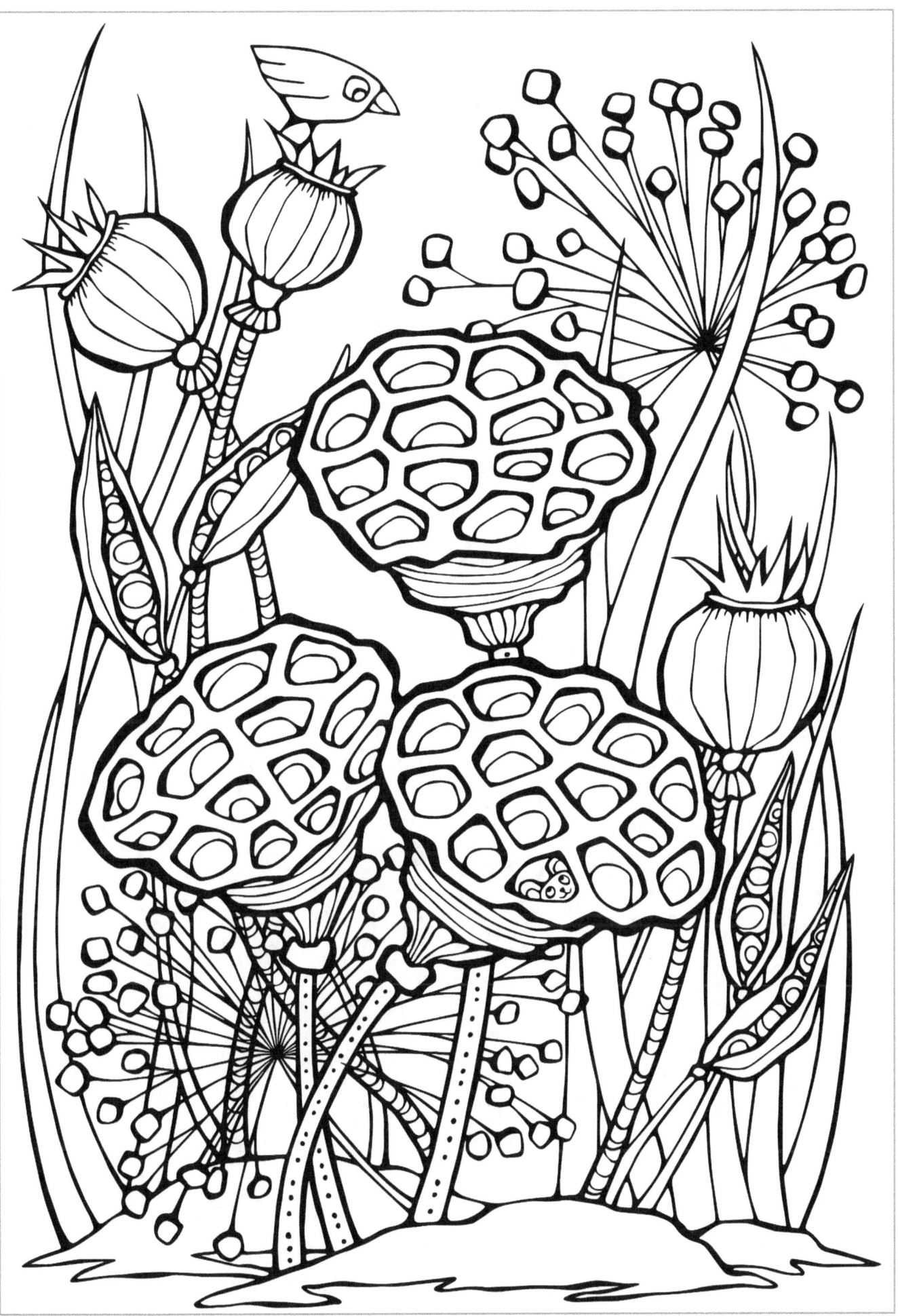

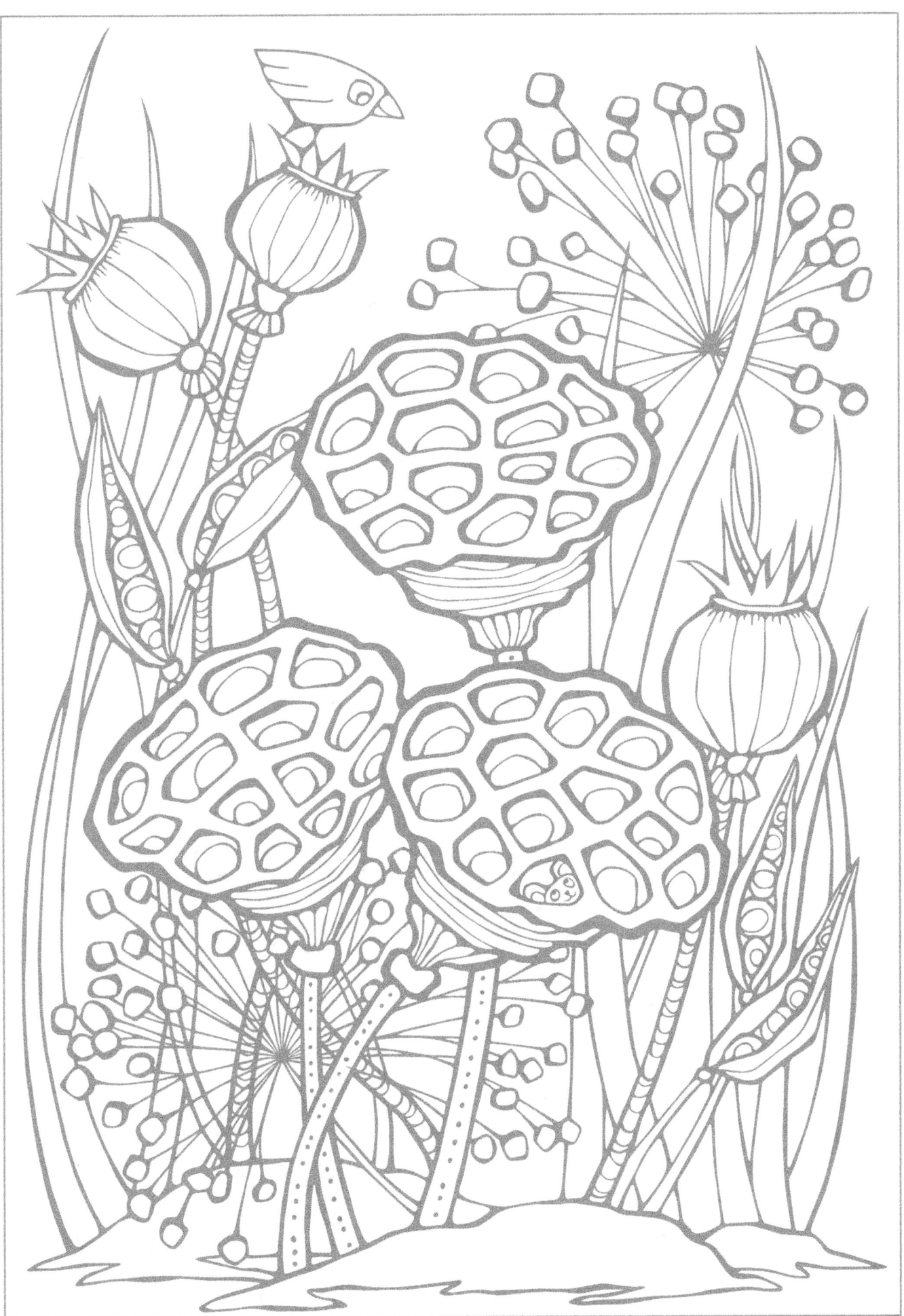

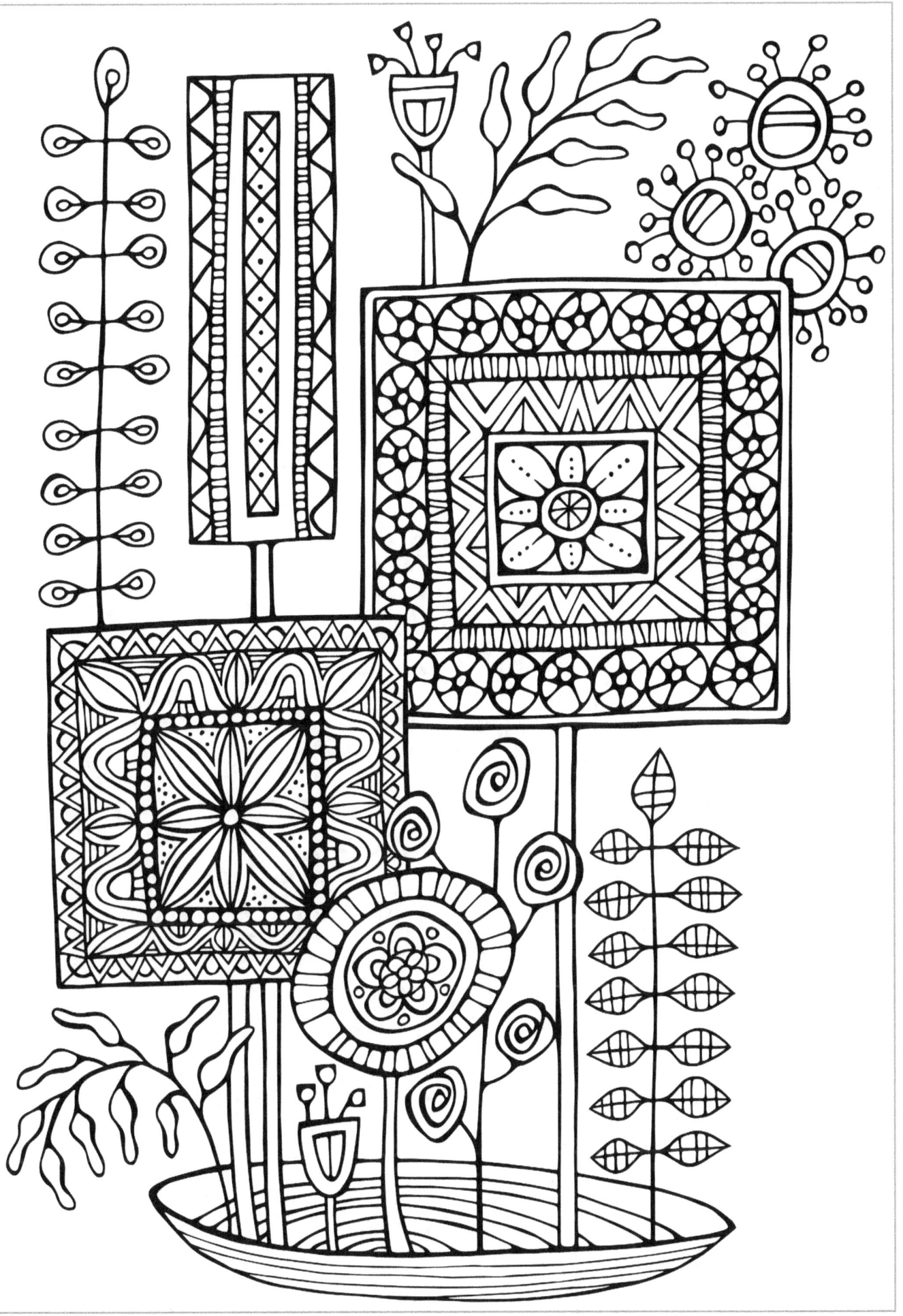

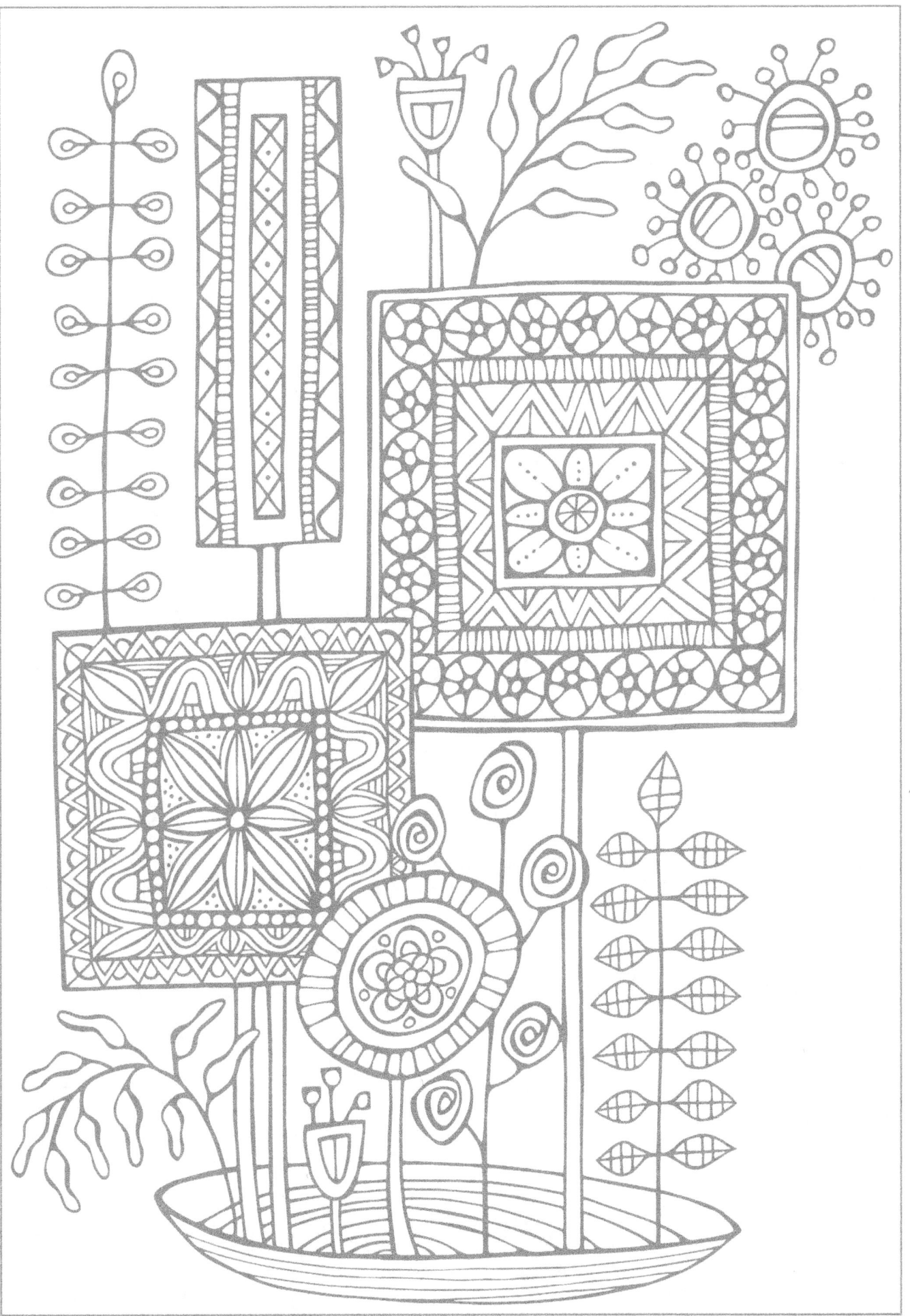

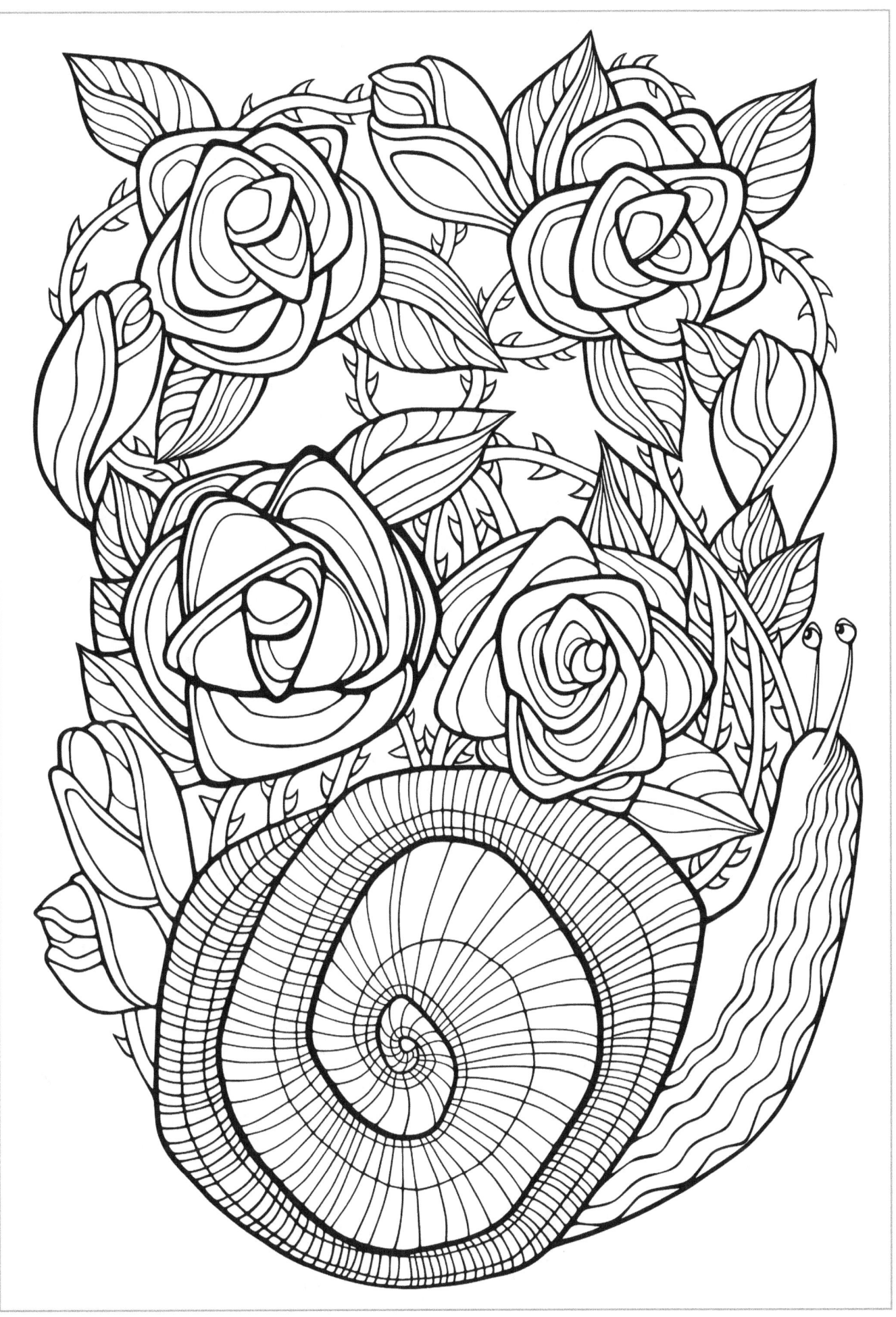

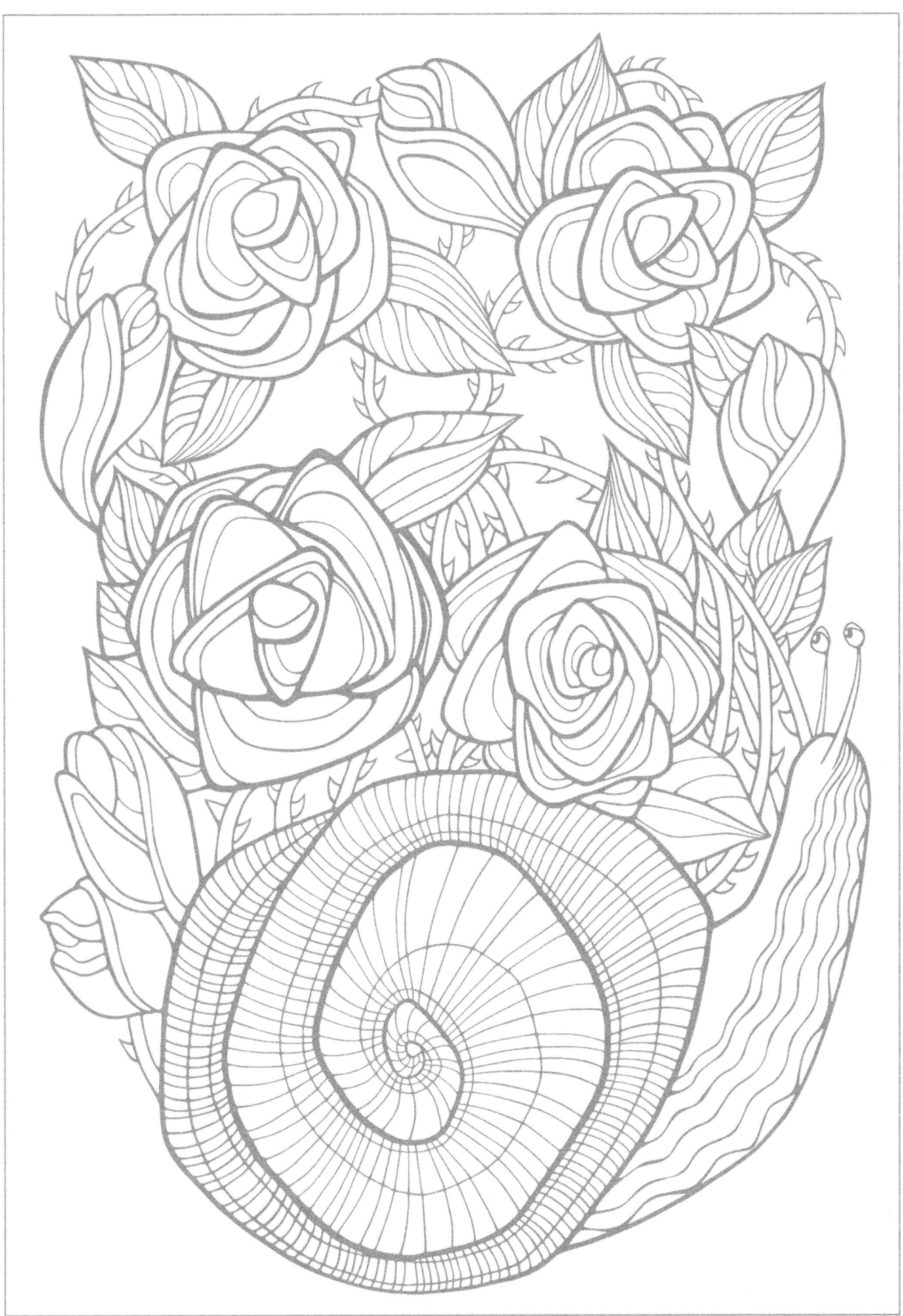

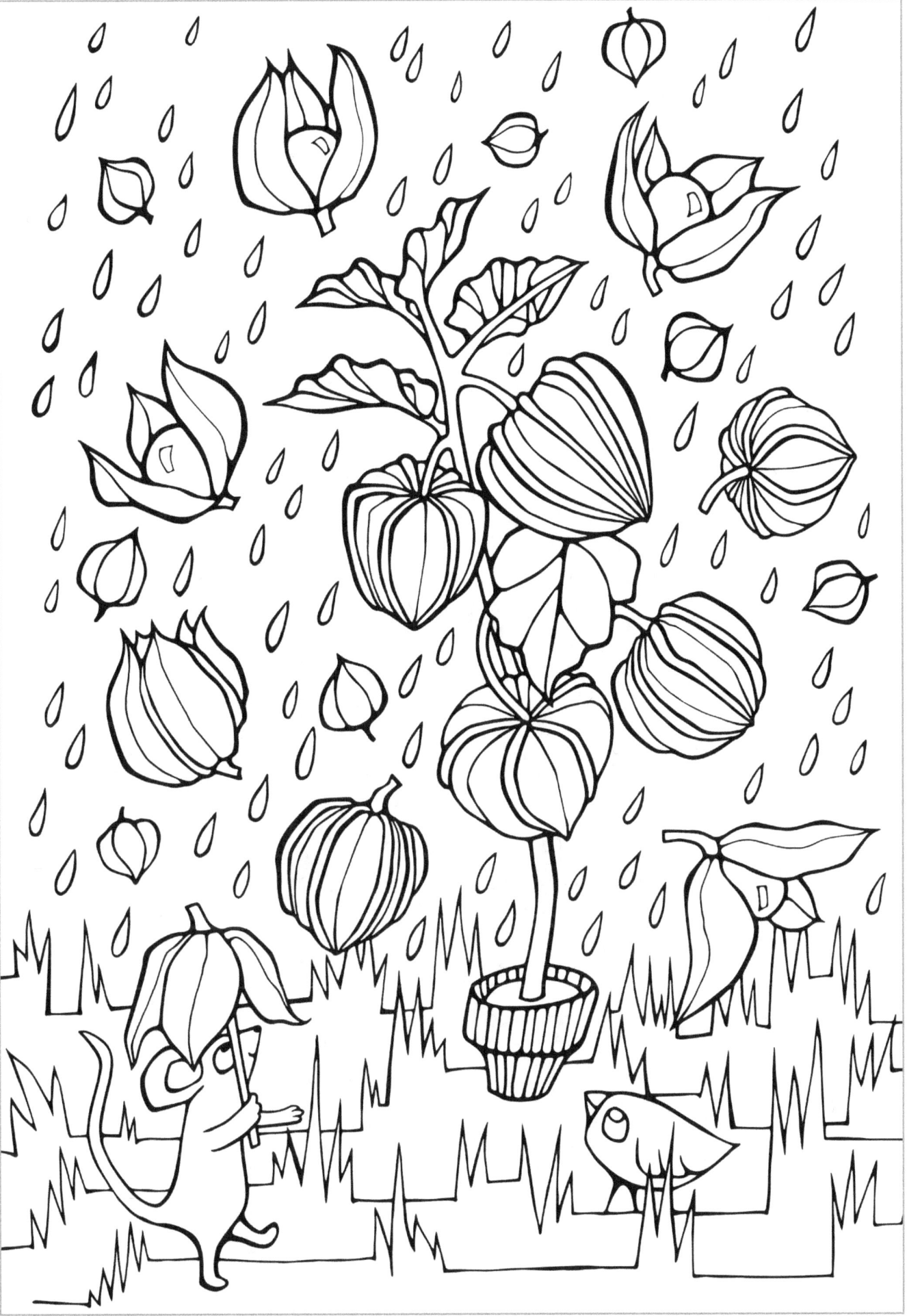

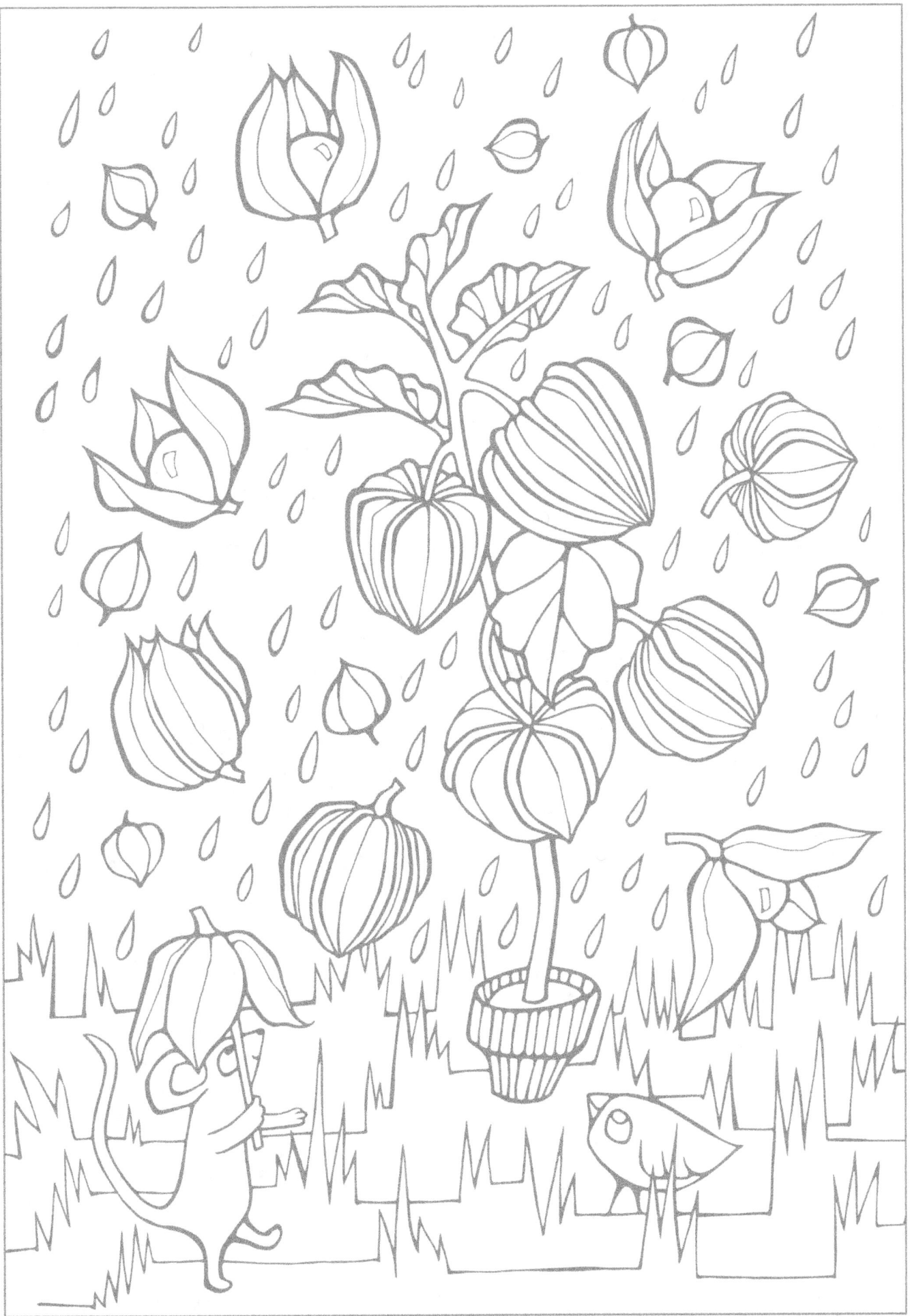

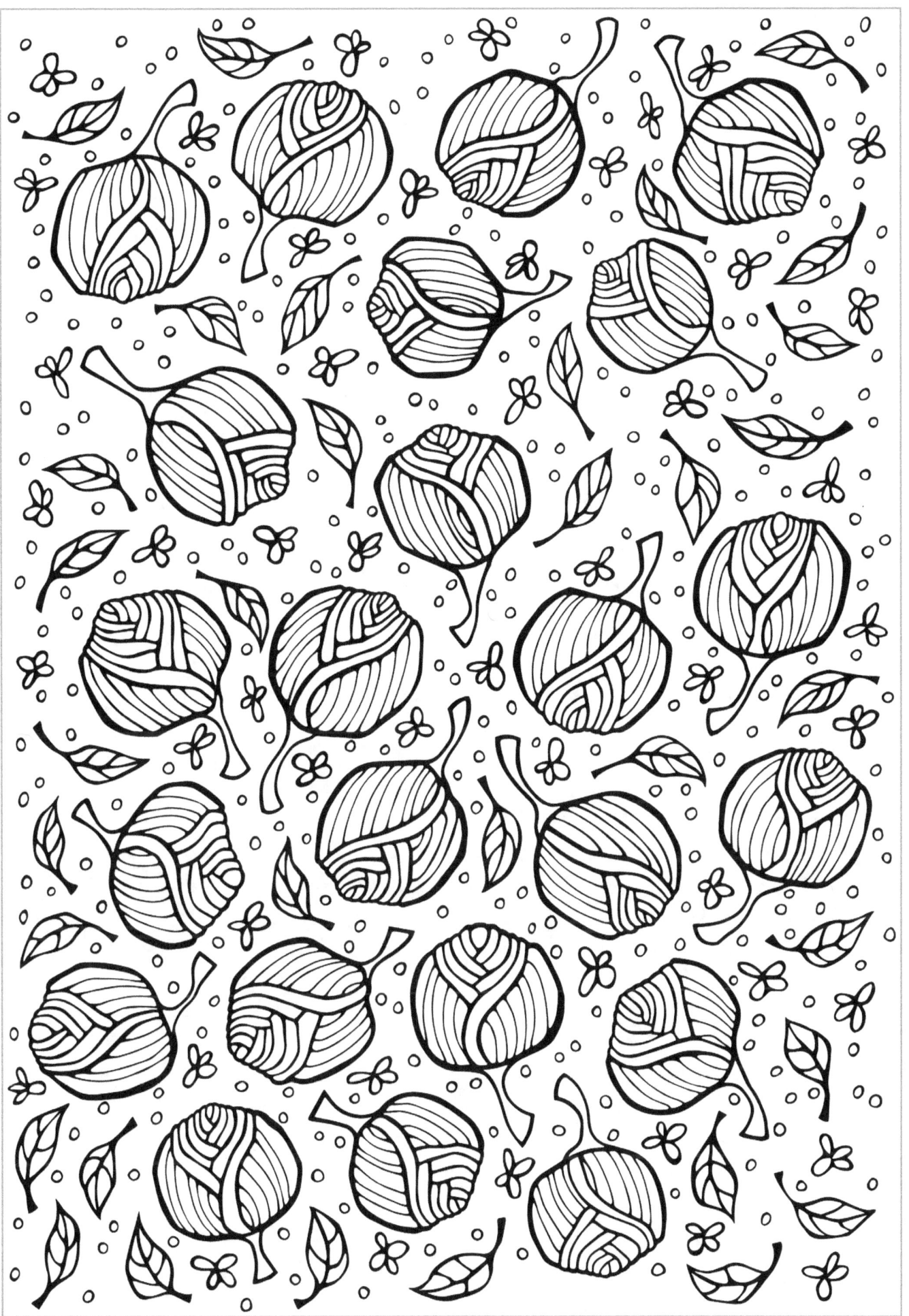

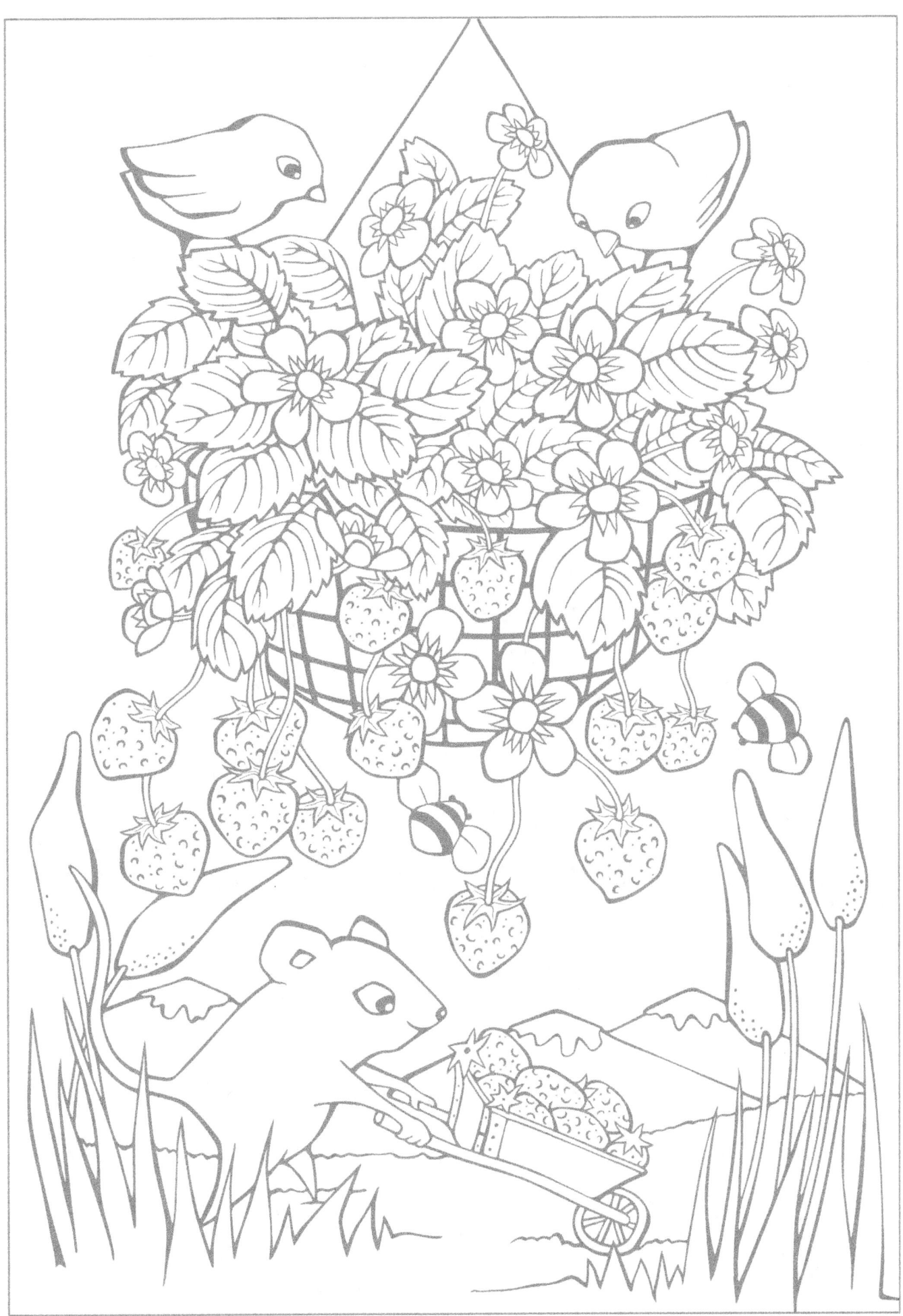

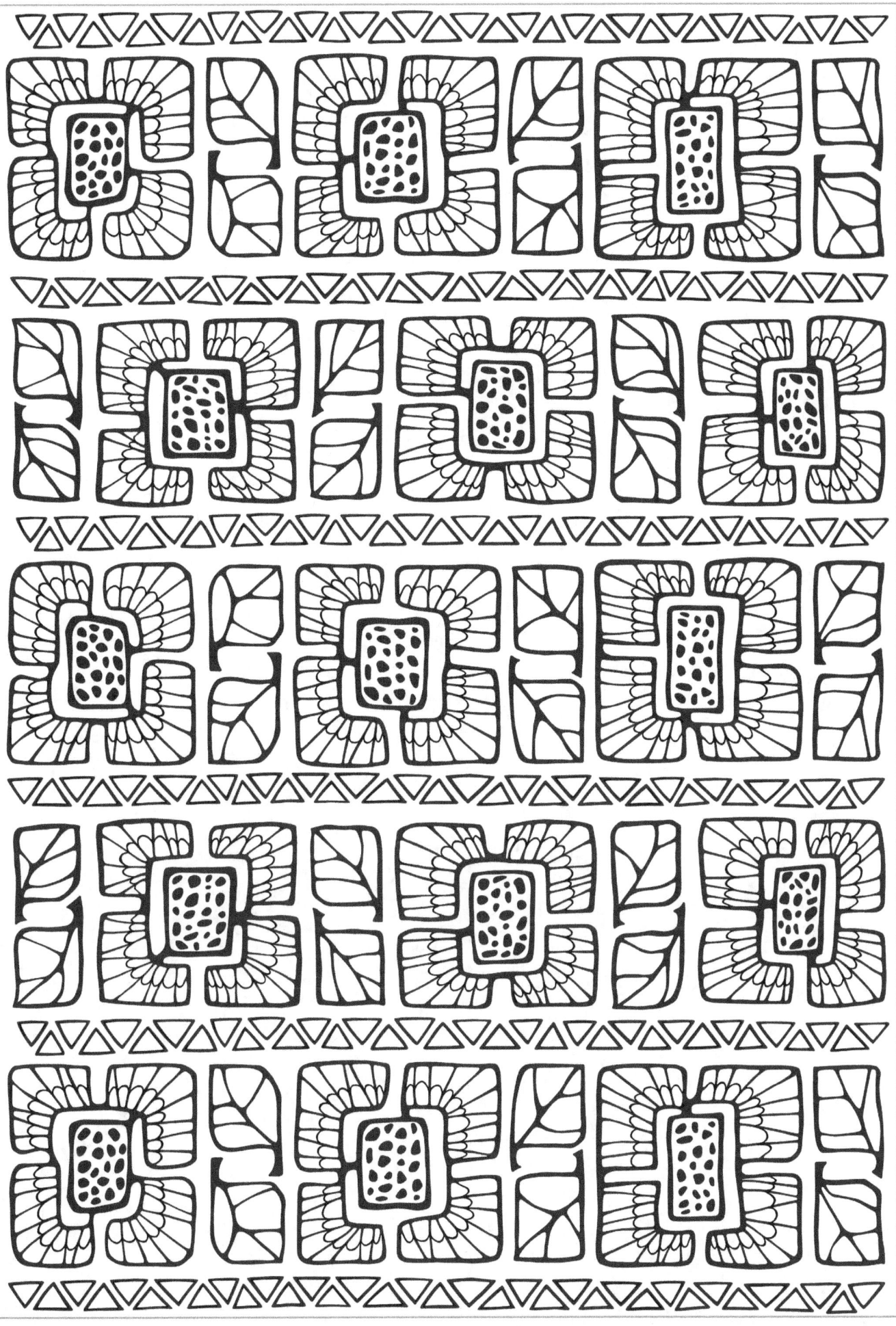

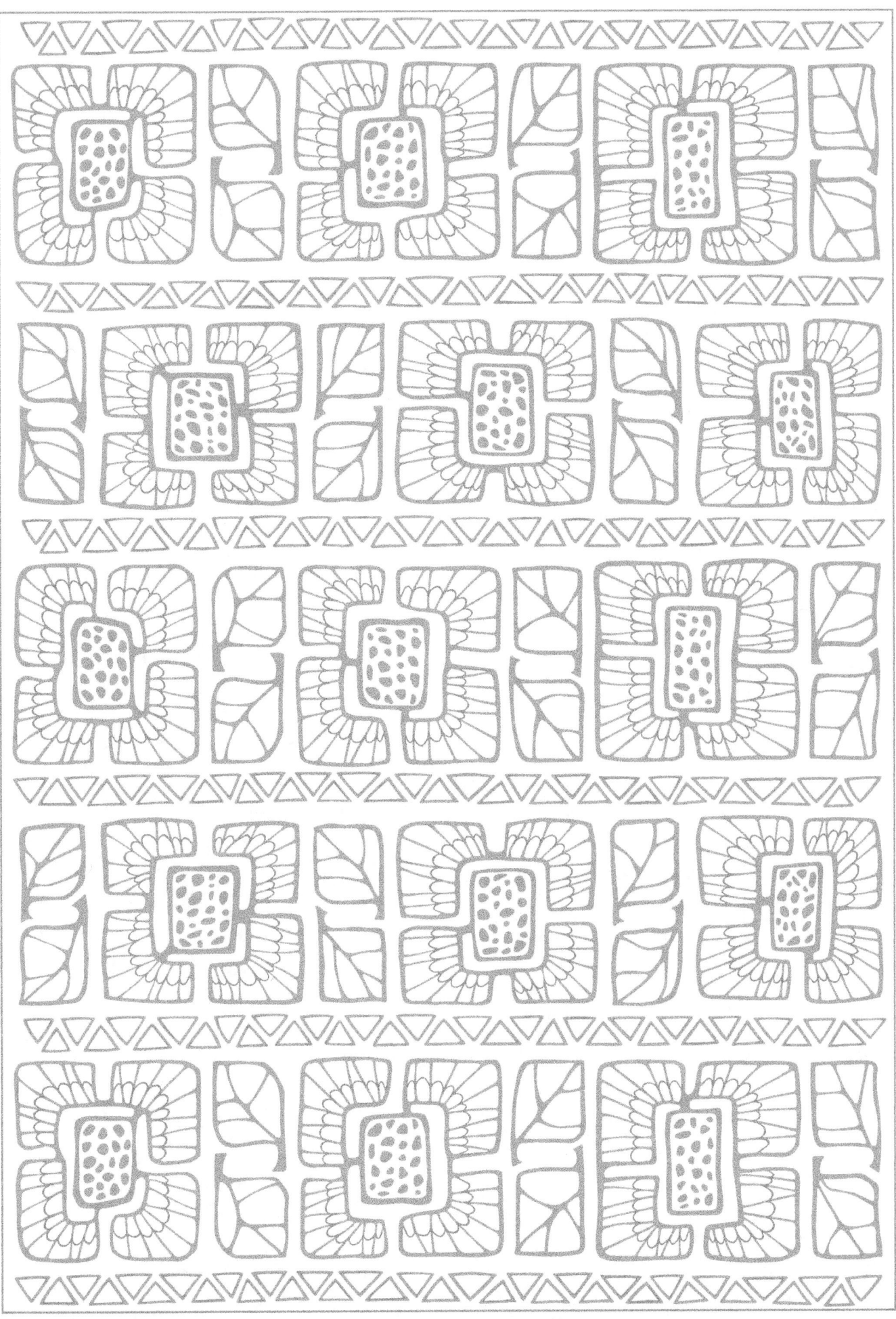

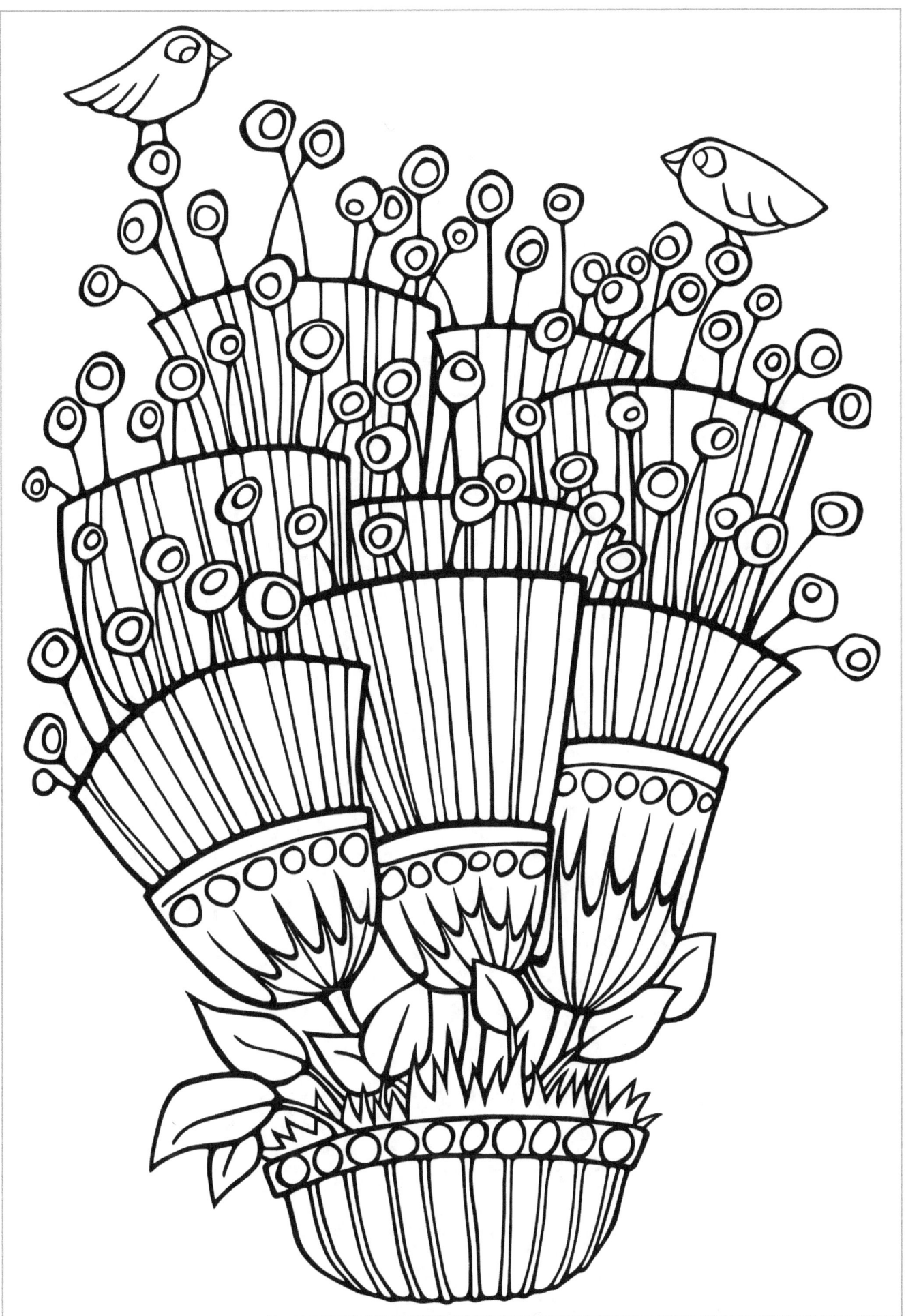

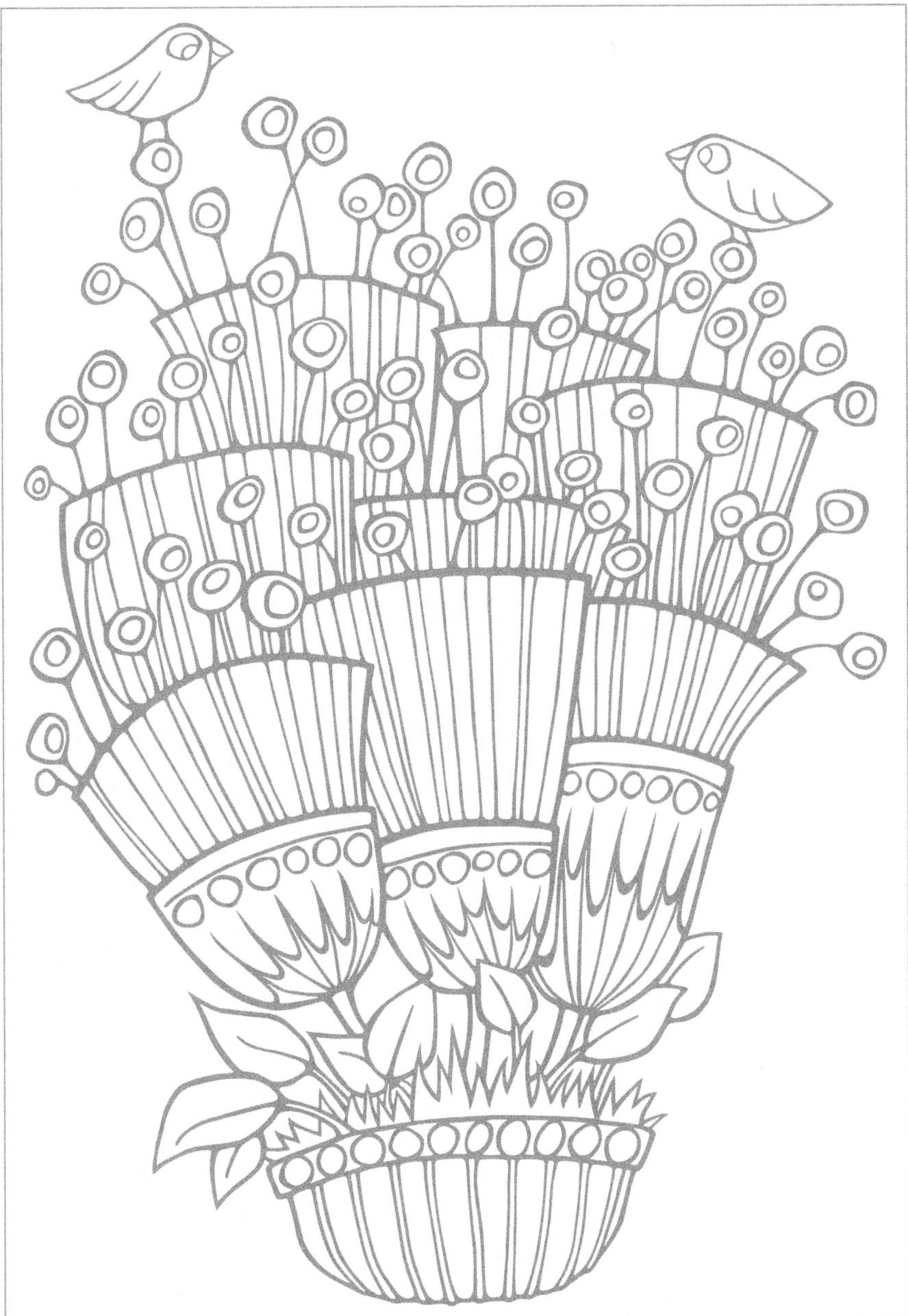

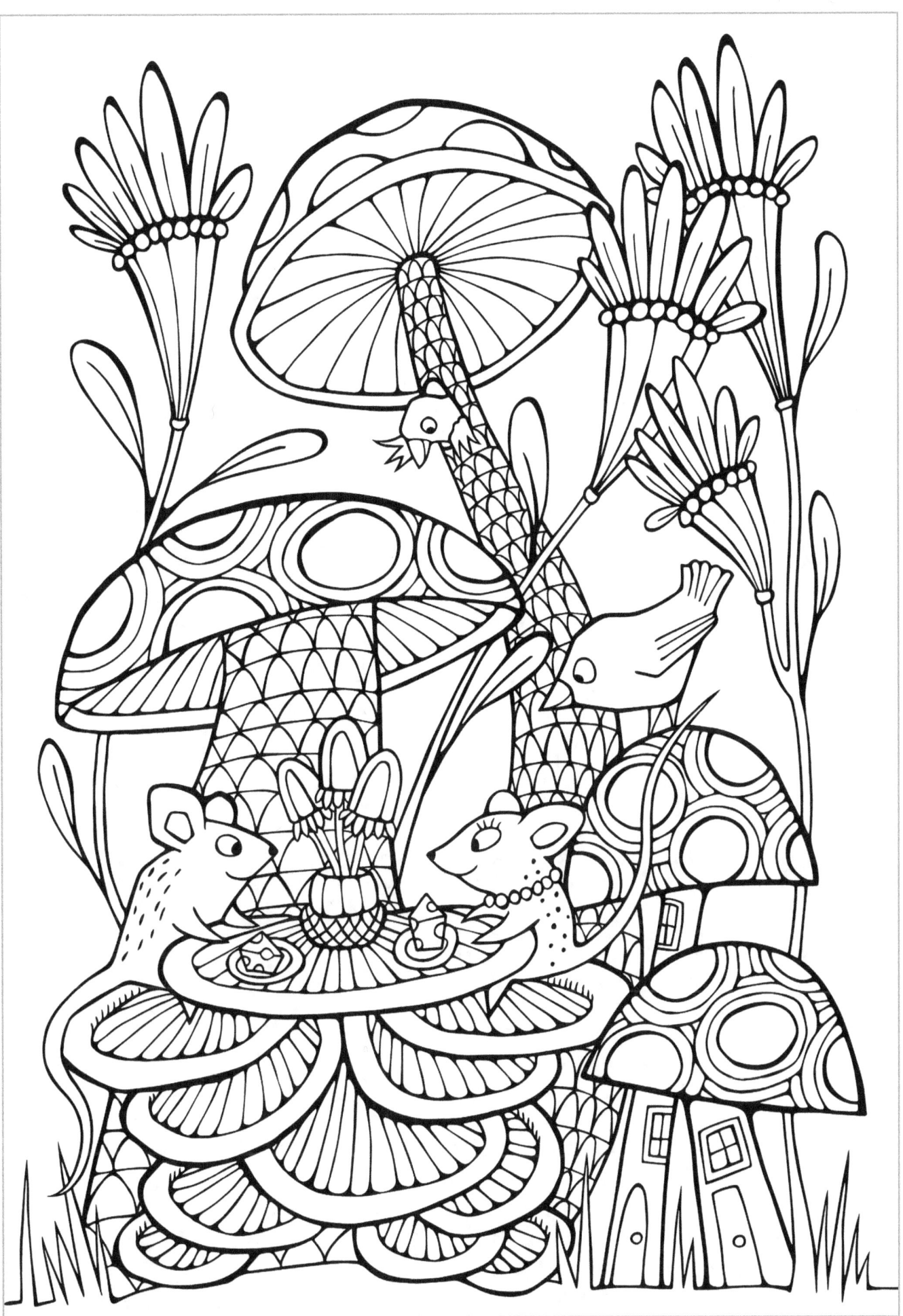

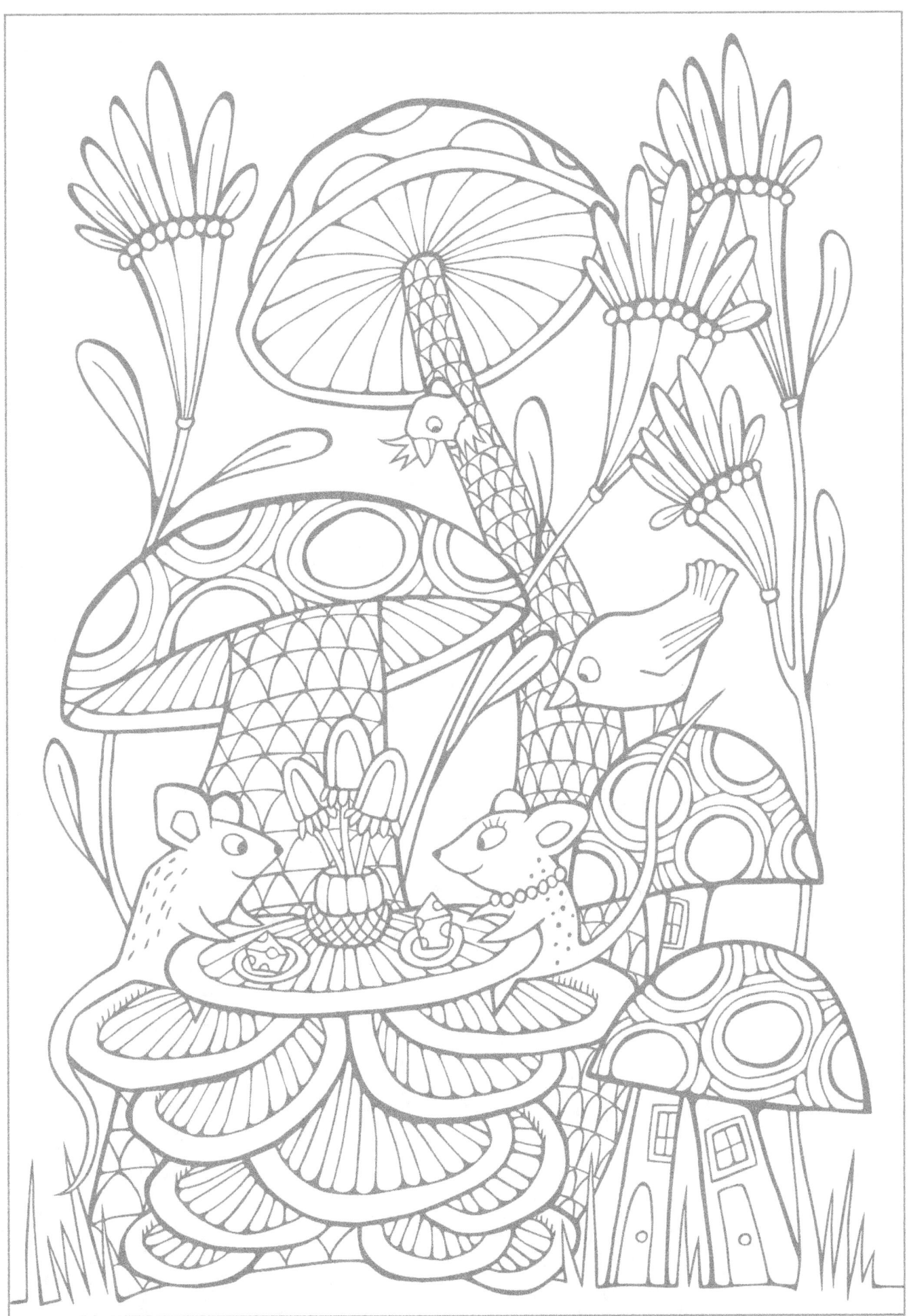

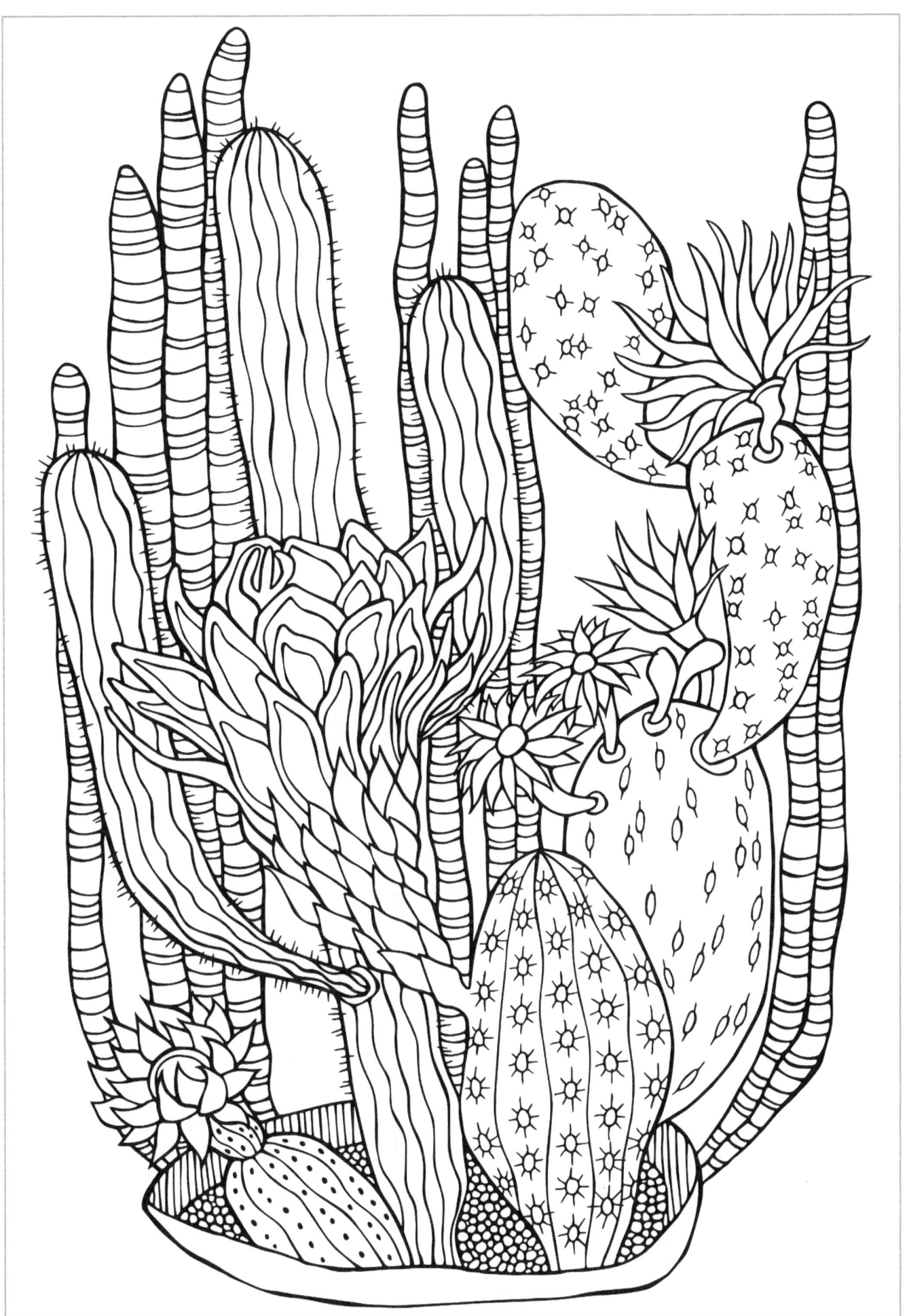

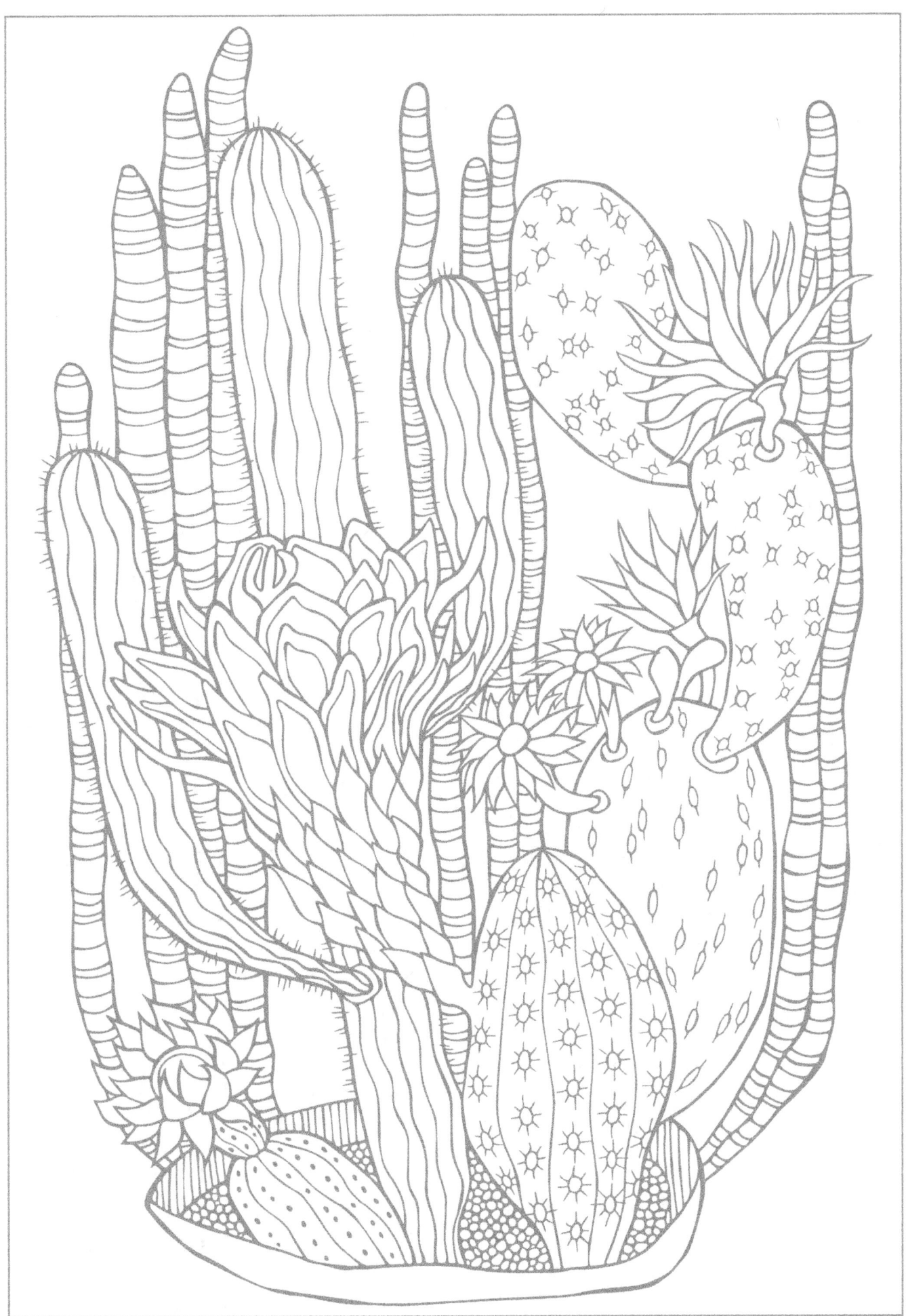

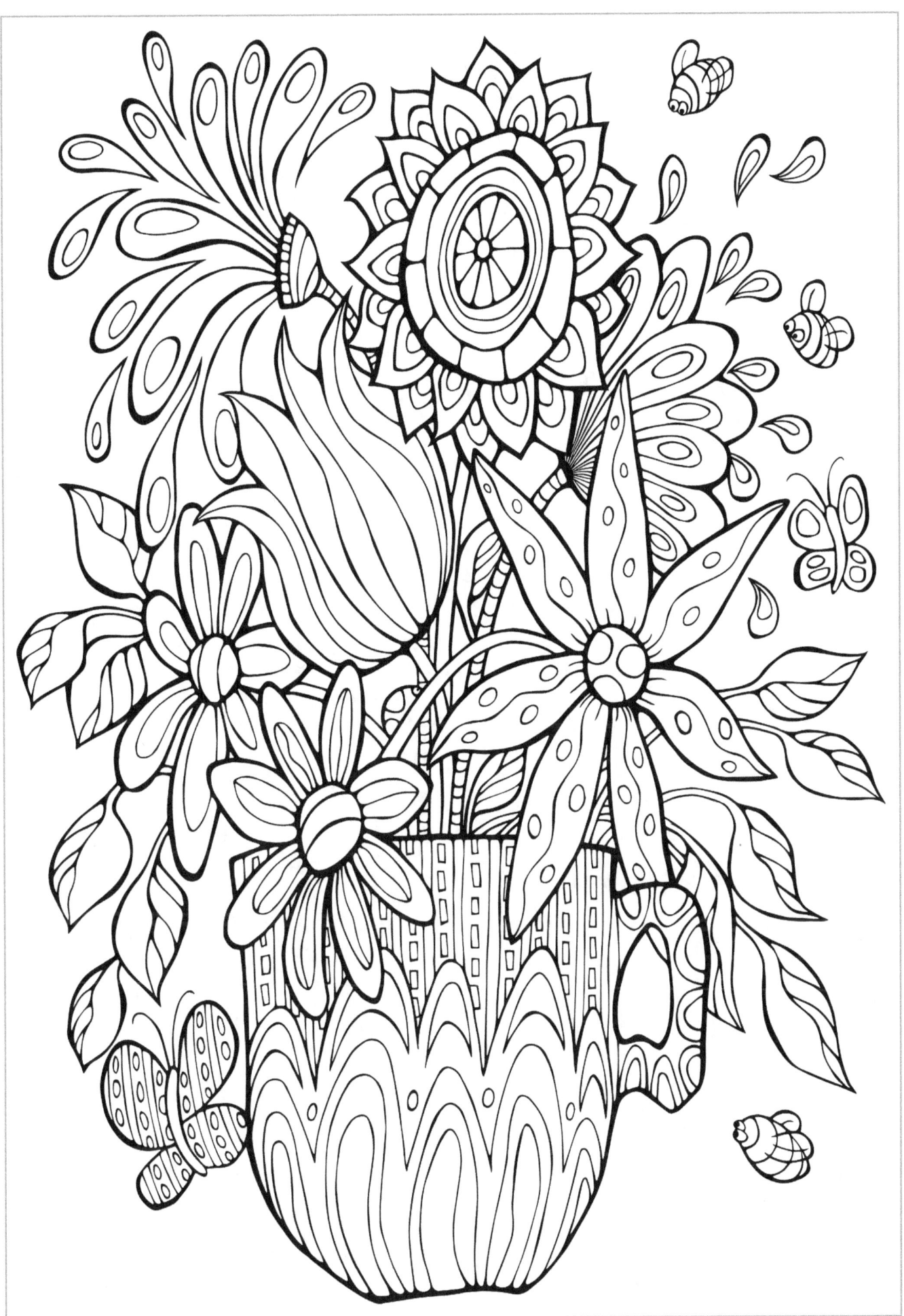

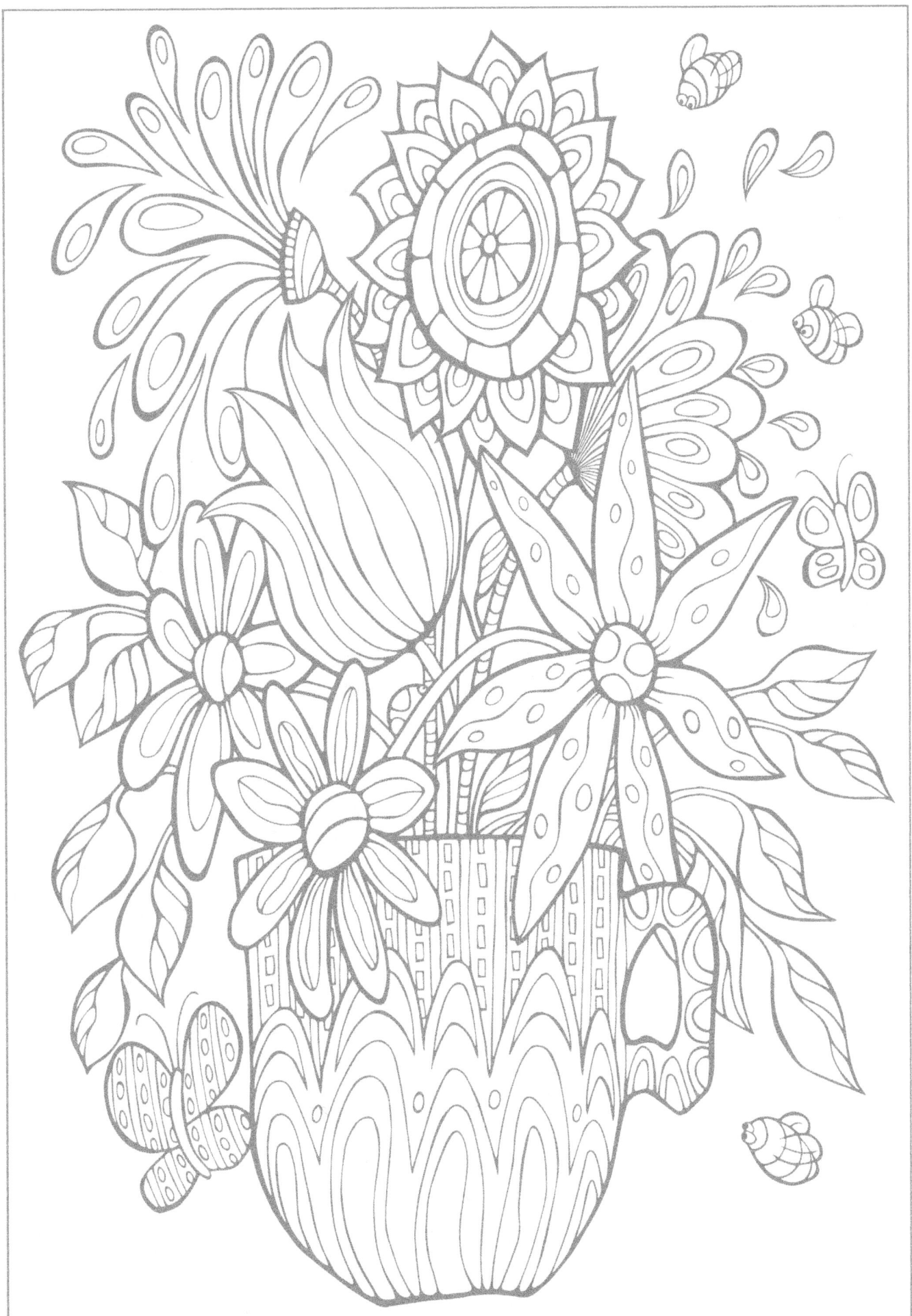

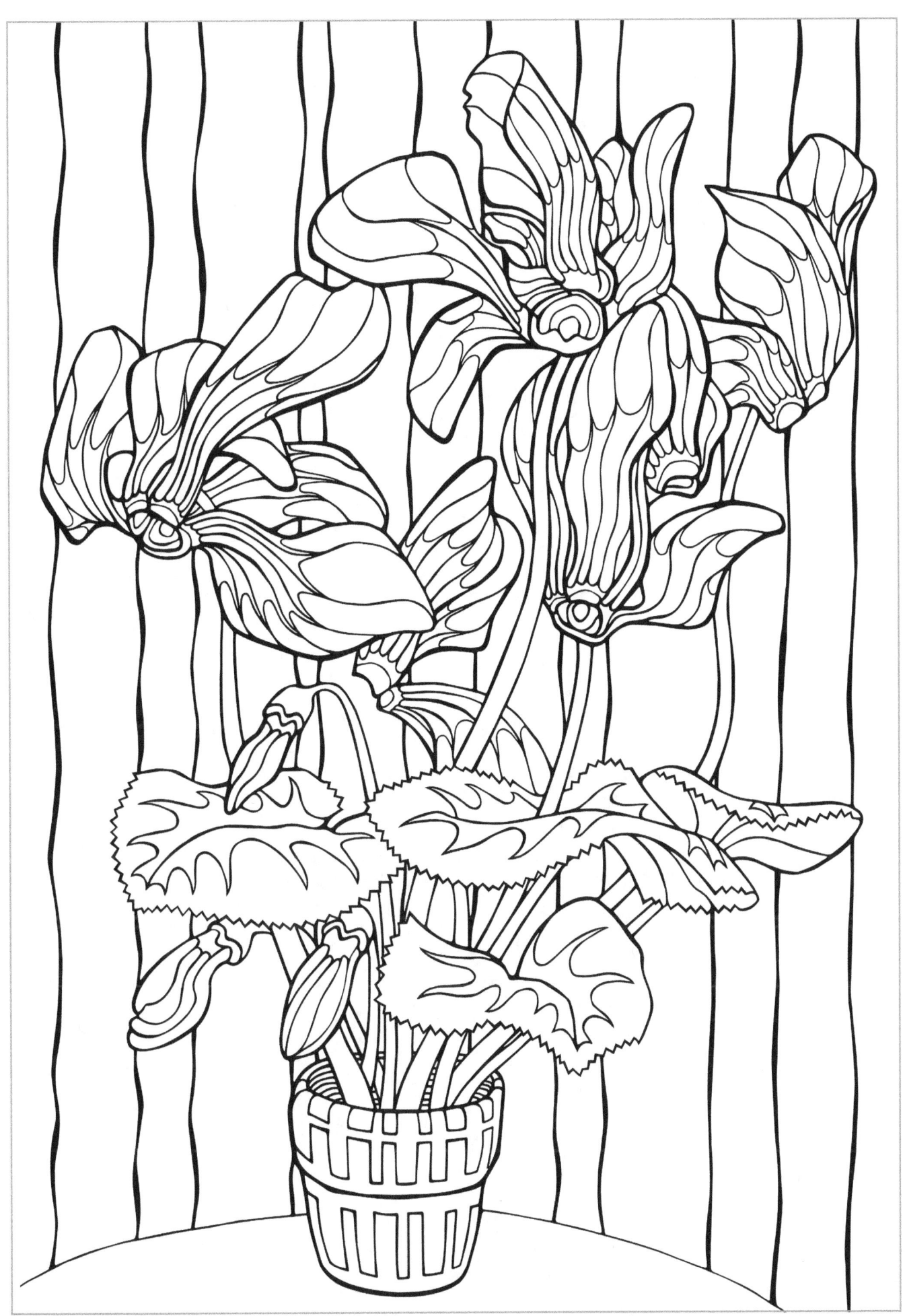

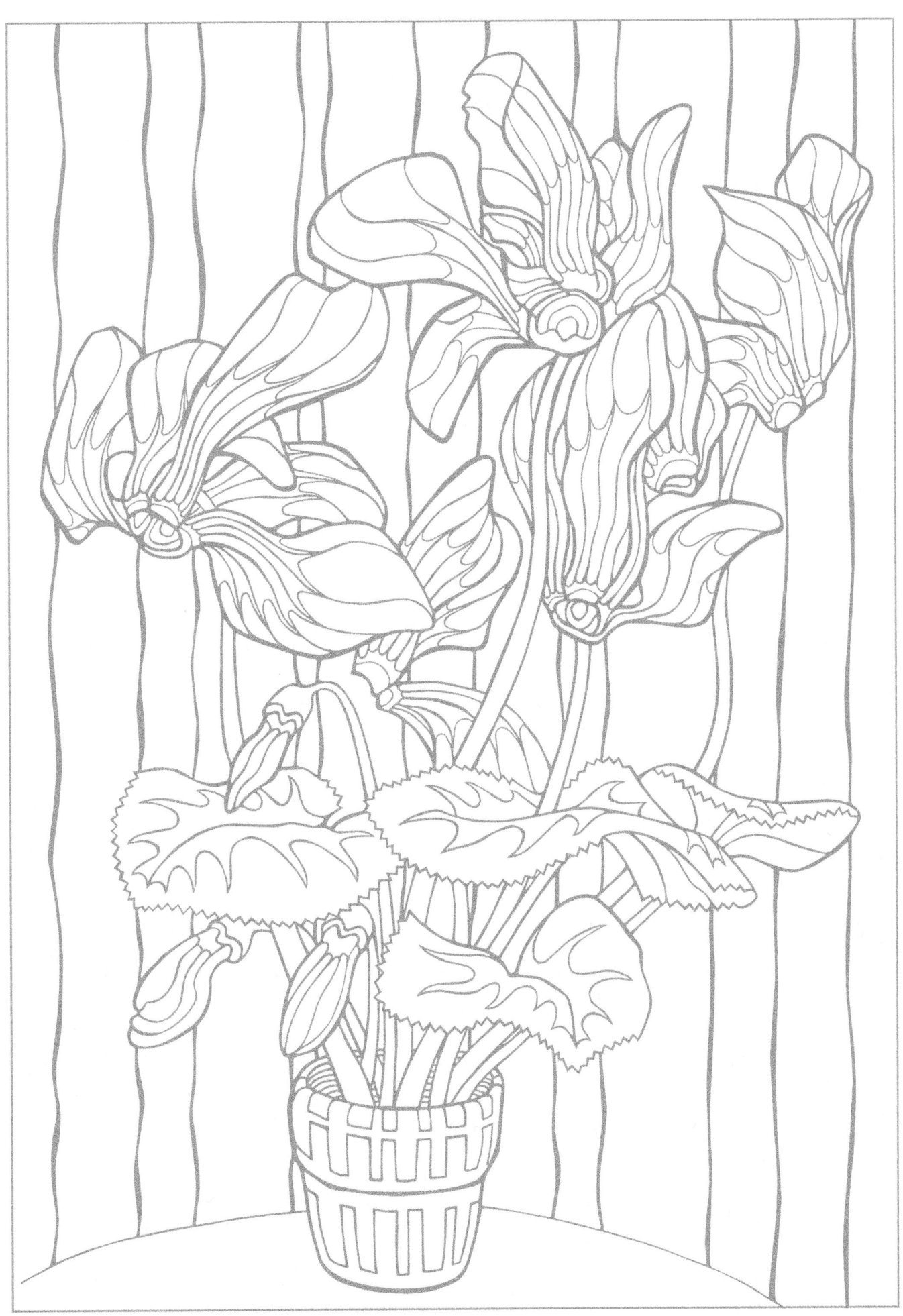

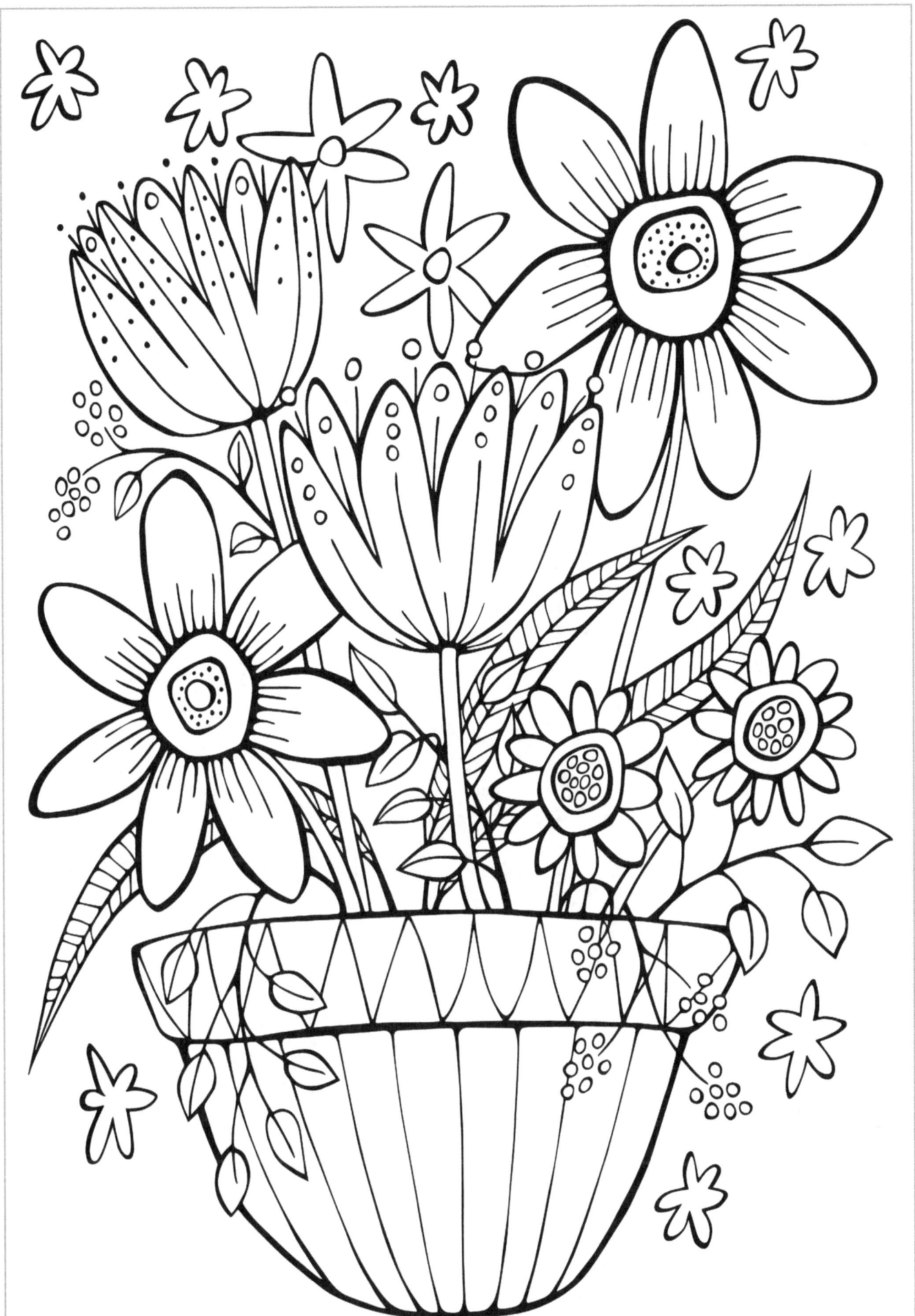

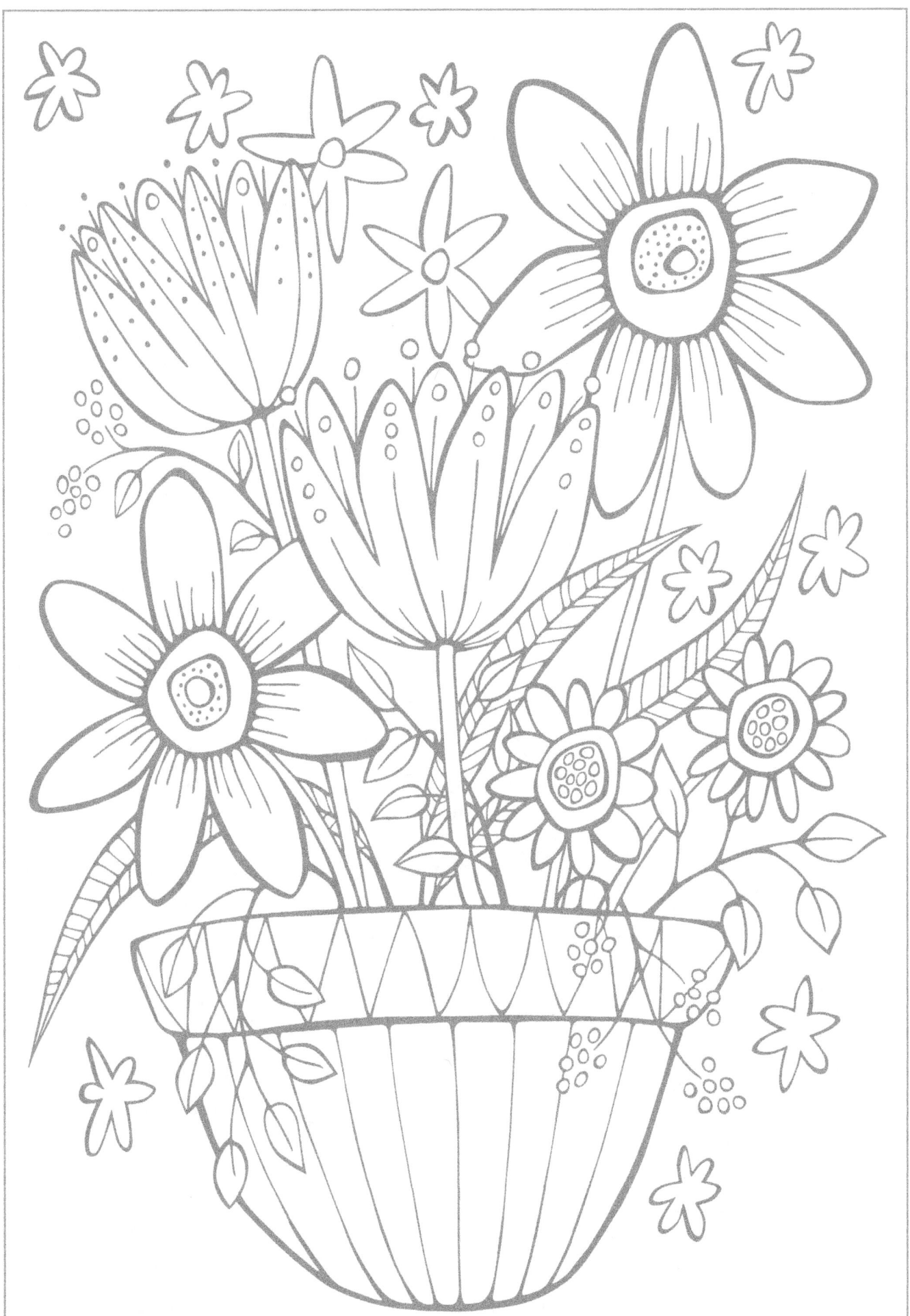

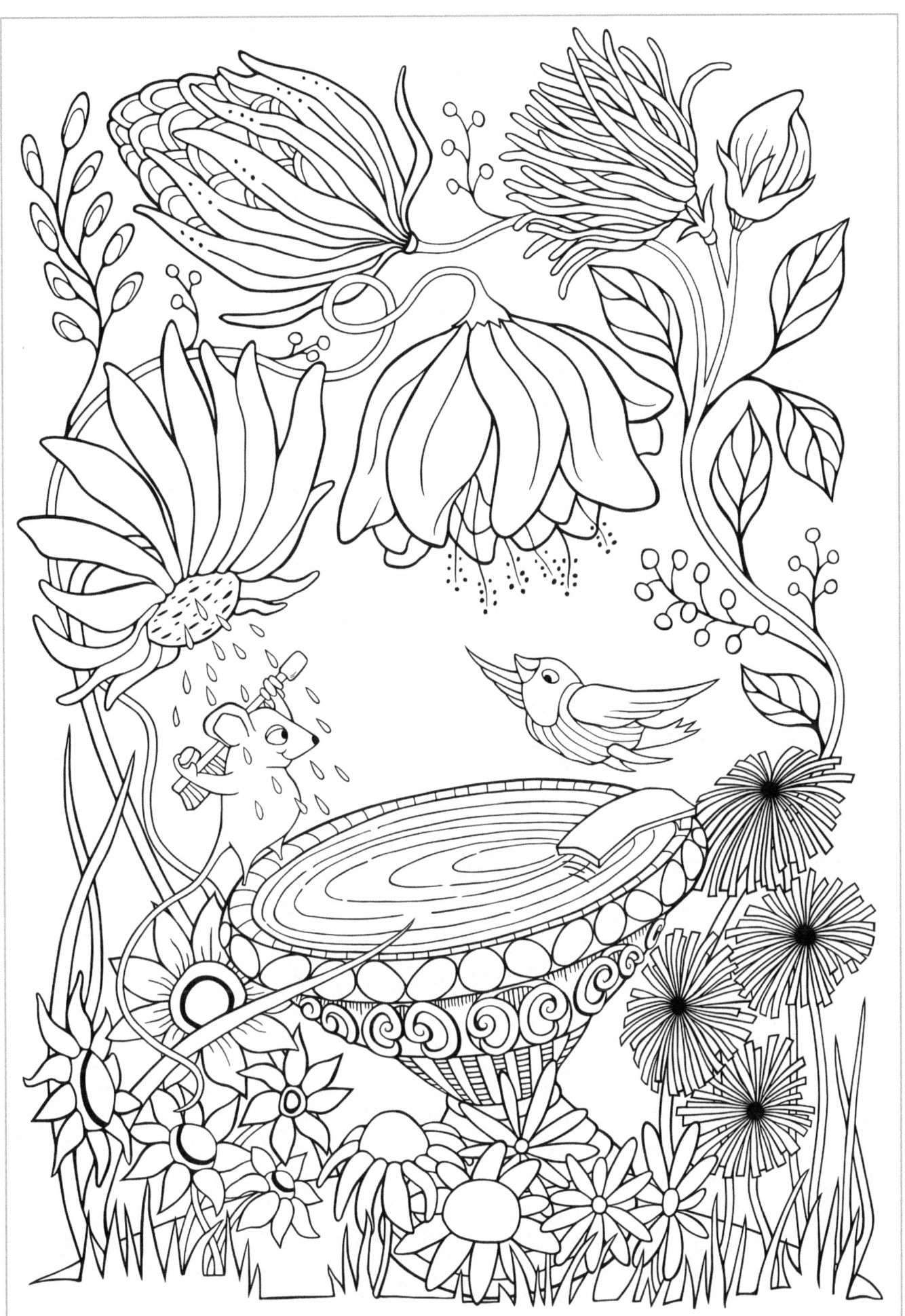

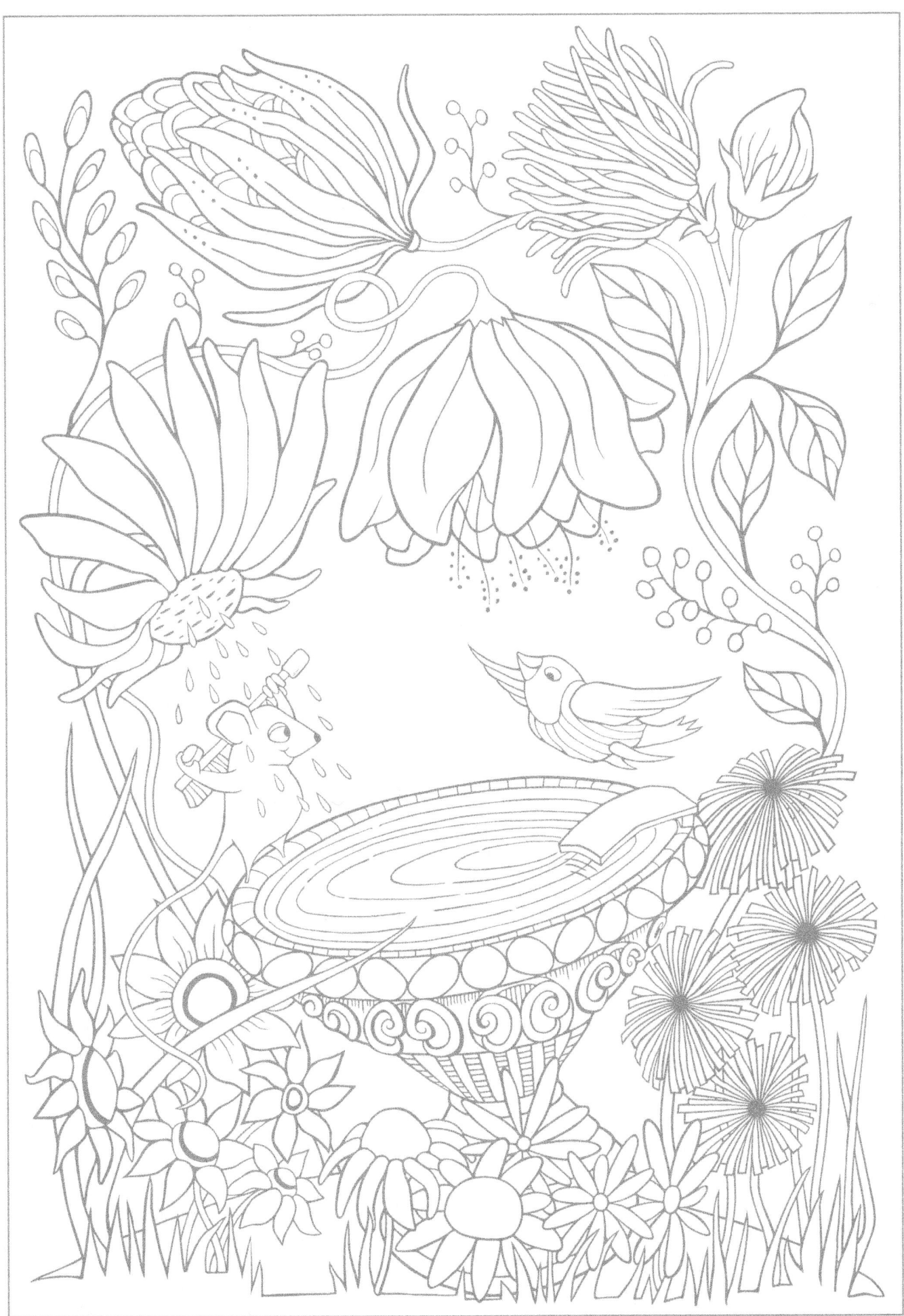

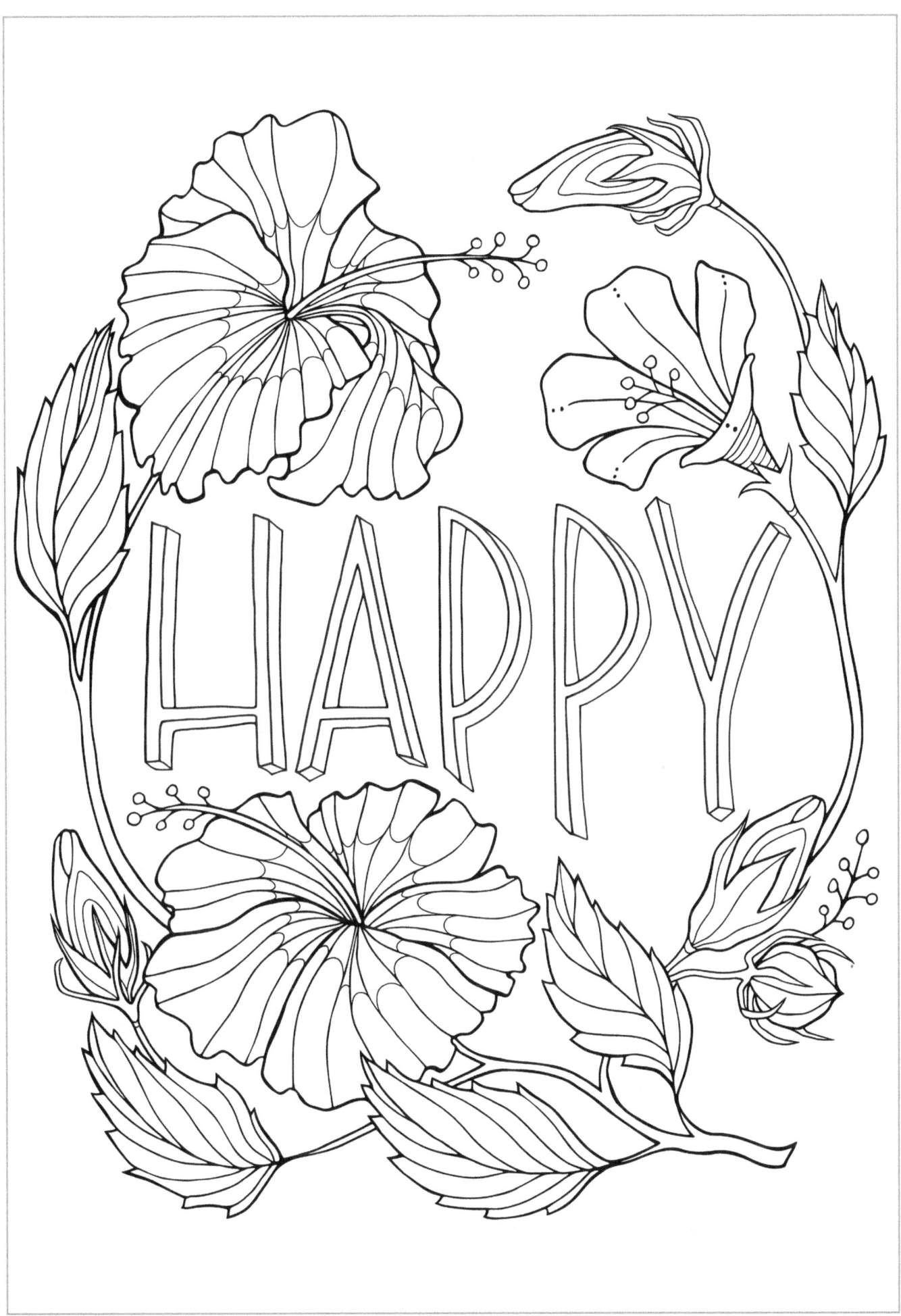

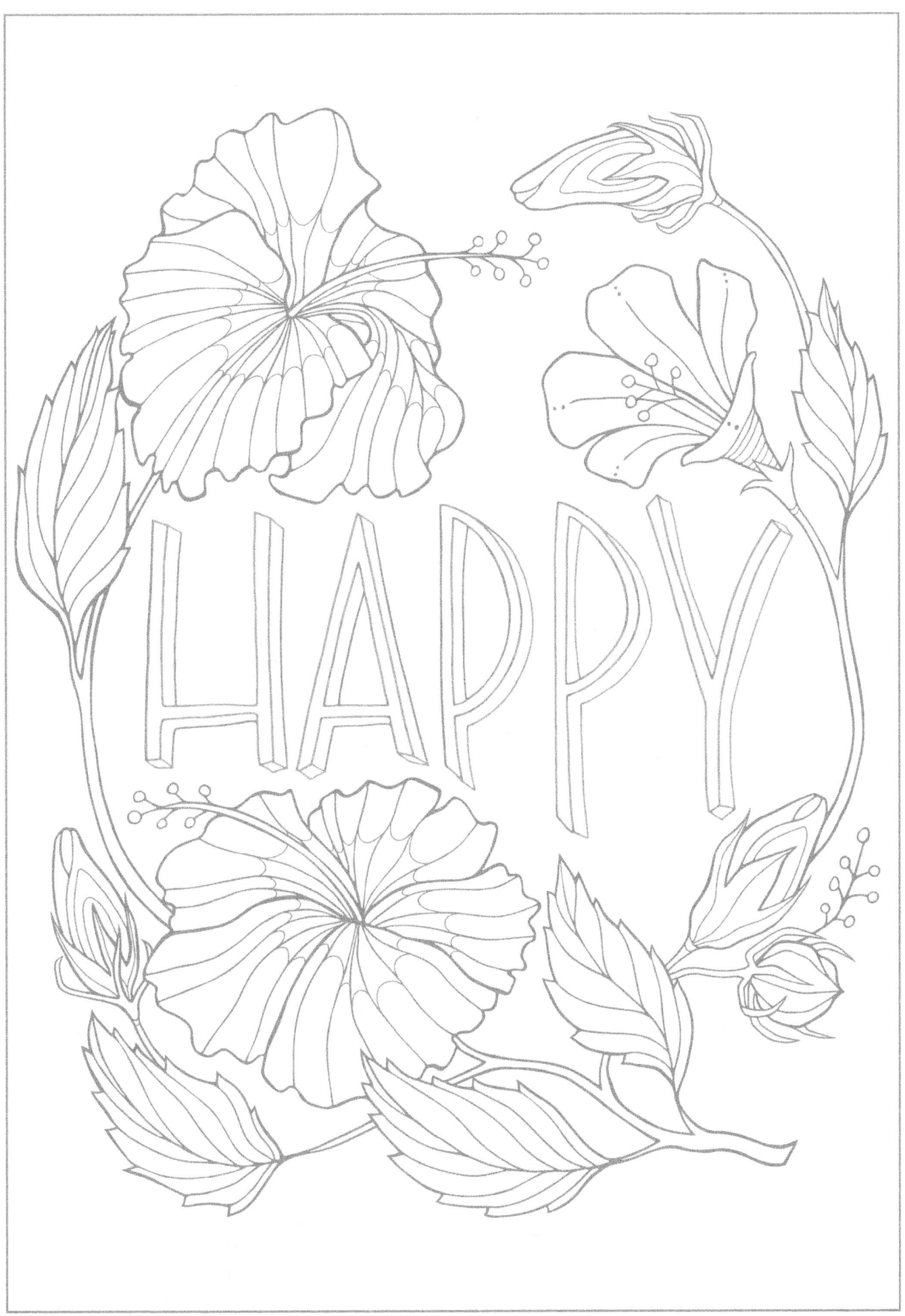

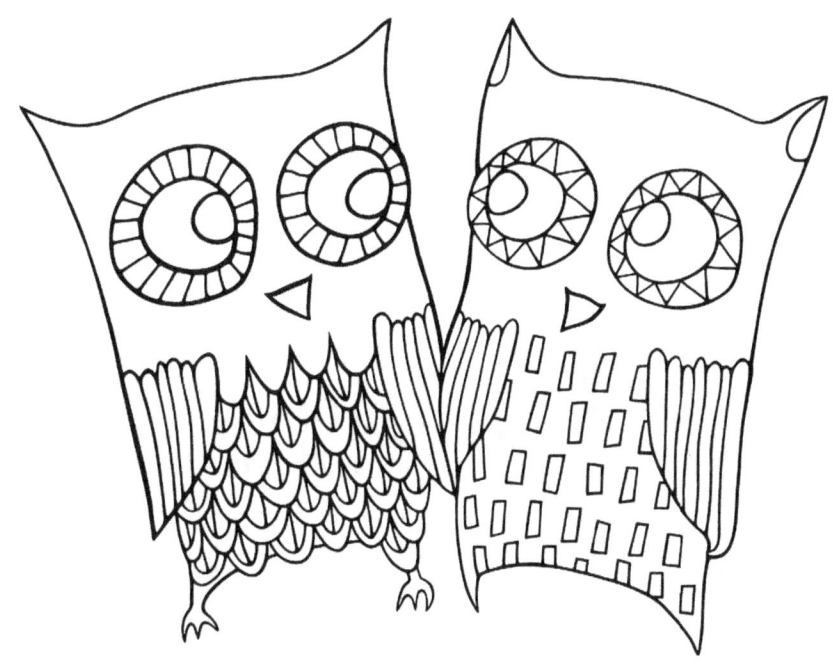

A Note from Mariana

The illustrations in this book started off as doodles, created during breaks from my work as a commercial illustrator and illustrator of children's books, drawn as a way of de-stressing, indulging in mindful, playful therapy. They gave me much pleasure and I hope that colouring them in will be as therapeutic, fun, and pleasurable for you as well. Enjoy bringing colour to life!

Please do join/follow me at:

Floating Lemons Colouring Pages on Facebook
Floating Lemons on Twitter
Floating Lemons Colour at Etsy

www.ingramcontent.com/pod-product-compliance
Lightning Source LLC
Chambersburg PA
CBHW062356220526
45472CB00008B/1824